BRITAIN **IN OLD PHOTOGRA**

LADYWOOD
LIVES

NORMAN BARTLAM

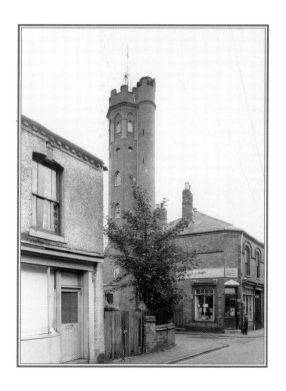

SUTTON PUBLISHING

Sutton Publishing Limited
Phoenix Mill · Thrupp · Stroud
Gloucestershire · GL5 2BU

First published 2004

Title page photograph: Perrott's Folly,
August 1968.

British Library Cataloguing in Publication Data
A catalogue record for this book is available from the
British Library.

ISBN 0-7509-3150-7

Typeset in 10.5/13.5 Photina.
Typesetting and origination by
Sutton Publishing Limited.
Printed and bound in England by
J.H. Haynes & Co. Ltd, Sparkford.

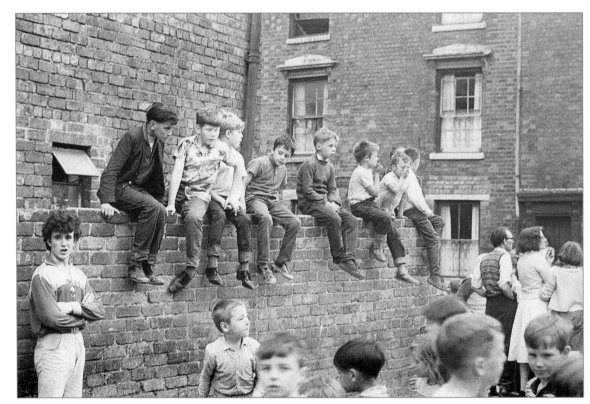

'Sit still, you might be in a book one day.' Children at play in the St Mark's Street/Alexandra Street area, *c.* 1964. (*Ingemar Lindahl*)

CONTENTS

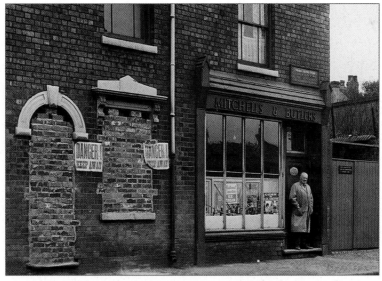

'And now the end is near . . .' in Springfield Street, May 1964.
Birmingham was in the middle of unprecedented demolition and
rebuilding, in this month when the Bull Ring opened, but for some it
was a case of waiting for the change to take place.

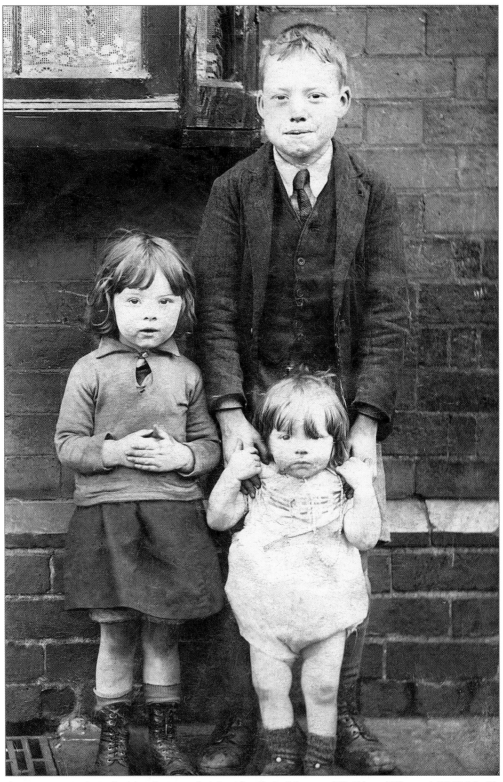

A rare opportunity to have a photograph taken for Chris, Mary and Kathleen Wilson at 32 St Mark's Street, mid-1930s. (*Jimmy Quinlan*)

INTRODUCTION

As the nation is flocking to see the third part of the Lord of the Rings trilogy, based on the books of J.R.R. Tolkien, who has Ladywood connections, I thought it right to bring out *Ladywood Lives*, my third book of photographs of old Ladywood. *Ladywood in Old Photographs* (1999) was followed by *Ladywood Revisited* (2001).

You might ask why nostalgia is so popular and why Ladywood in particular. Apart from these books at least two other people have produced books about old Ladywood, there is a website on the area, a thriving Old Ladywood Reunion Association and a Ladywood History group. All groups continue to unearth new photographs and stories, rarely duplicating what has already been published.

Perhaps one of the reasons why people are so interested in the past is that things are changing so quickly and there is a desire to preserve the memories of what the area was like. At the time of writing massive, new, upmarket residential developments are being constructed, wiping away the derelict factories on Ryland Street and Sherborne Street, and canalside redevelopment, nice to look at as it is, has wiped away the industrial buildings on Browning Street and parts of Sheepcote Street. The whole of the area from Freeth Street up Icknield Port to the canal is currently up for redevelopment, so soon that will be just a distant memory. By flicking through the pages of *Ladywood Lives* present-day residents can see what it must have been like in the 1950s when the first round of redevelopment hit Ladywood.

Luckily not all the past is being demolished. St John's Church celebrates its 150th anniversary in 2004, Perrott's Folly is set to get a new lease of life and Spring Hill Library currently stands in splendid isolation, following the demolition of the appalling Brookfields Shopping Centre. The former Baldwin's paper bag factory in Morville Street still stands; at least the façade does, as new residential apartments are built on to it. How much commitment to Ladywood will these new occupants have? At least Ladywood has managed to keep its name, unlike other nearby areas, but present-day Ladywood residents and workers are asking: 'How will the social make-up of the "new" Ladywood change the area? Where will the community spirit go?' Those readers who left Ladywood

during the 1950s and 1960s redevelopment may well have had similar thoughts and may well believe that the community spirit disappeared then. However, many people, especially the elderly, stayed and battled on to stabilise the community. Today there is a thriving Ladywood Neighbourhood Forum that continues to strive to do just that. In short: Ladywood Lives. That seemed to be a good enough title for this book. I hope you will agree.

Details of both *The Brew 'Us Bugle* and The Old Ladywood Reunion Association, run by Gordon Cull, which organises reunions and issues a newsletter, can be obtained from Norman Bartlam, c/o the Ladywood History Group, Ladywood Arts & Leisure Centre, Monument Road, Ladywood, Birmingham B16 0QT. Thanks must go to Gordon and many other past and present Ladywood people for their help during the compilation of this book, particularly Johnny Landon, Eileen Doyle, George Elmer and Anthony Spettigue.

All uncredited pictures are from the author's collection.

Norman Bartlam, 2004

1

Streets, Scenes
& People

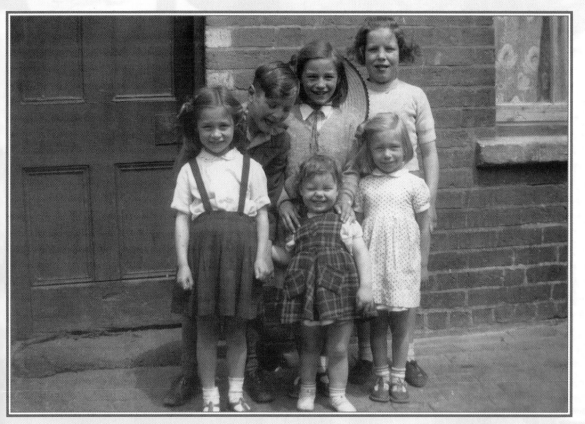

Maurice, Jean, Pearl, Rita, Angela and Norma – friends in Shakespeare Road, *c.* 1950.
(*Alicia Foxall*)

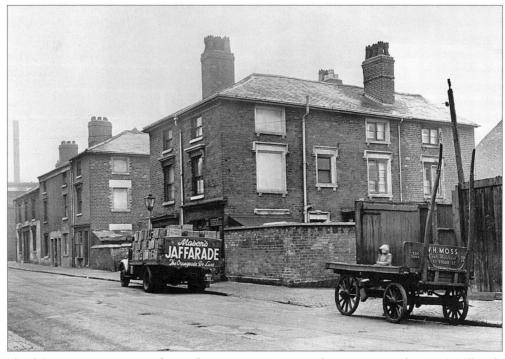

The delivery man pops in to the outdoor on Stour Street with more crates of Mason's Jaffarade drink, while a little girl seems to be waiting patiently for the horse to arrive for Billy Moss's coal wagon. (*Johnny Landon*)

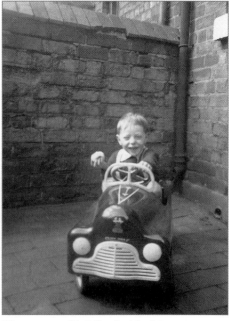

A reasonably quiet scene, at Spring Hill near the library, 1960s.

Three-year-old Colin Smith drives across his yard in New Spring Street, *c.* 1955. (*Percy (Bill) Smith*)

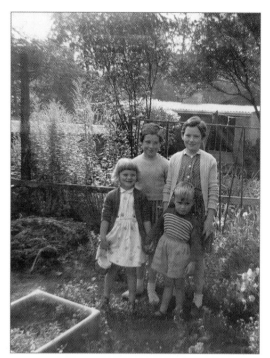

Rita and Bridget Timmins in Ellen Street.

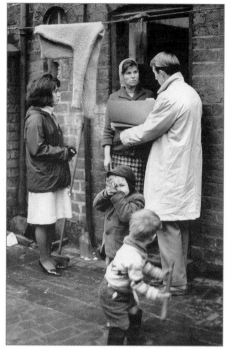

Students carry out a survey of residents in Ingleby Street, 1964.

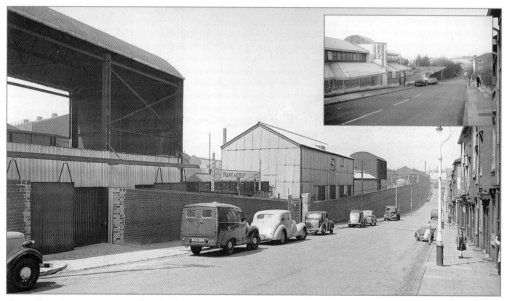

Cope Street, June 1956. The first few cars on the left are outside Frank Moseley's autosales and there is a large advert for Armstrong Siddeley. The railway, which runs down the side of the street, is hidden from view by the buildings on the left. This was taken in the week British Rail abolished third class coaches on trains. Other occupants of the street include shops run by Mrs Sharp, and Messrs Woodley, Smith and Sleigh. One of the factories at the far end near Steward Street was Britachrome Co. Ltd. Inset: The scene today, showing the new health centre. (*Johnny Landon*)

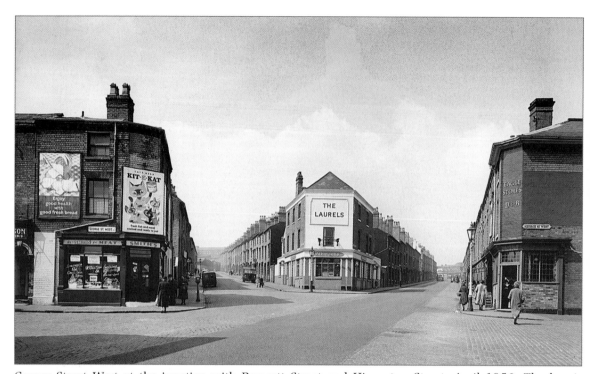

George Street West at the junction with Prescott Street and Hingeston Street, April 1956. The bus is travelling along Hingeston Street towards the junction of Pitsford Street and Crabtree Road. The scene is dominated by the Laurels pub and the butcher's shop run by Mr Smith. The shop is plastered with advertisements for Kit-e-Kat, 'fresh fish and meat cooked and ready to eat' and one for bread, which reads 'enjoy good health with good fresh bread'. The Eagle Stores is on the opposite corner where customers were no doubt talking about the wedding of actress Grace Kelly to Prince Rainier of Monaco. (*Johnny Landon*)

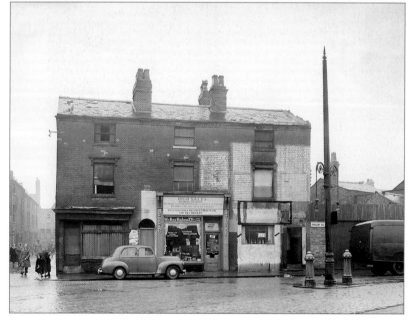

High Sales radio & TV shop on Ingleby Street, May 1952. An advertisement states: 'With the help of 6", 8" or 12" recordings you can record weddings or parties in your home.' It also urges people to 'Have Your Voice Recorded Here with EMI Records'. The *New Musical Express* was just months away from launching the Top 12 hit parade. The Top 20 started two years later, and this did much to improve the sales of records in shops like this one. The lettering down the side of the shop may at first glance look Scandinavian but it isn't!

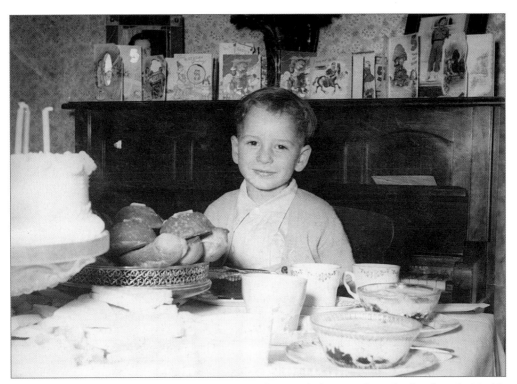

Jimmy Quinlan celebrates his fifth birthday at his Nan's house where he lived in St Mark's Street, 1952. (*Jimmy Quinlan*)

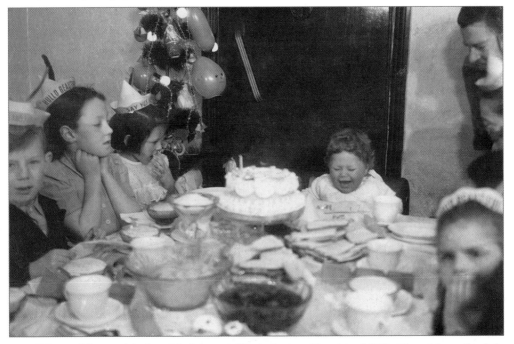

Ray Usher celebrates his first birthday at 29 Anderton Street in 1951. The girl on the left, wearing the hat saying 'Hullo Beauty', is his neighbour, Caroline Forrest. (*Ray Usher*)

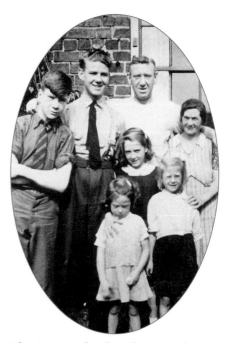

Ken Salmon, who lived at 29 St Mark's Street. The handwritten note on the back reads: 'Spiv days, he was a best friend of Eddie Fewtrell, ex-spiv selling stockings and later the night club king'. (*Terence Salmon*)

The Canning family at home in their railway workers' house on King Edward's Road. Left to right: Geoff (fourteen), Stan, Mr and Mrs Canning. The young girls are Vera, Iris and Rosie. (*Iris Fawcett, née Canning*)

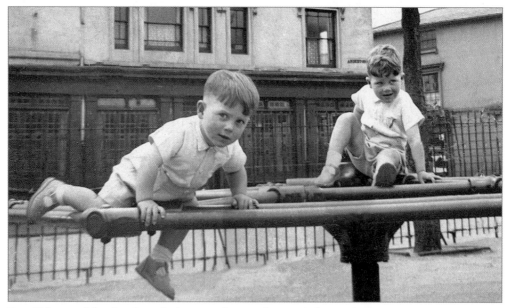

Ray Usher and his brother Graham, right, at play on 'The Rec', the recreation ground on Anderton Street, *c.* 1955. The pub behind them is the Bell on the corner of Anderton Street and King Edward's Road. (*Ray Usher*)

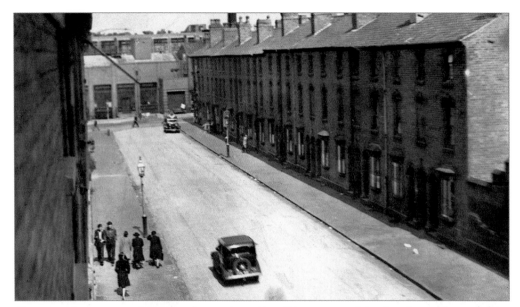

There was not too much traffic about when Alan Wyant popped his head out of an upstairs window and took this view along St Mark's Street. The factory at the end of the street is part of Bulpitt & Sons on Summer Hill Road. (*Alan Wyant*)

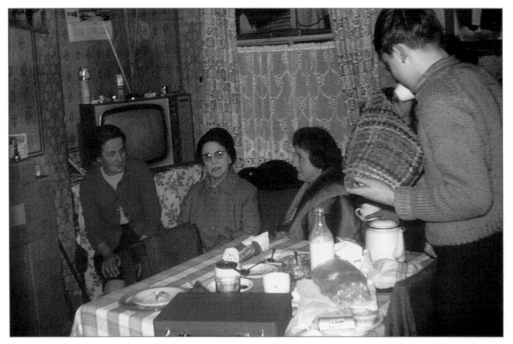

This photograph was reproduced from a colour slide, which was rare in the days when it was taken in the mid-1960s. It shows the interior of 16 Shakespeare Road; Ken Greaves who lived there was a keen photographer. Nora Greaves, Ken's mother, is seated with his Nan and Dorothy Chapman, his auntie. His brother Michael is carrying the teapot, which is covered in a not-so-rare woollen tea cosy. The box on the table contains Ken's slides. The state-of-the-art television in the background was probably bought from Sweeney's. (*Ken Greaves*)

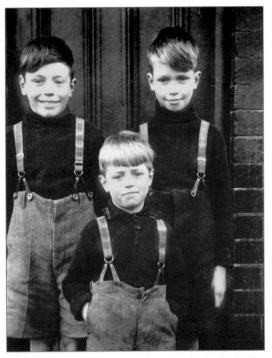

Mr Jukes, Edie Ockford's granddad, who
lived at the back of 71 St Mark's Street.
(*Edie Ockford*)

Three members of the Greaves family at the back
of 34 Shakespeare Road: Trevor, aged twelve,
Ken, aged ten, and Clifford, *c*. 1953. (*Ken Greaves*)

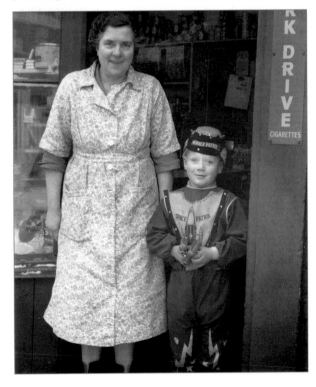

Elsie Price, outside her shop at
29 Anderton Street, 1956. The lad
beside her is her 'Space Patrol'-
loving grandson Ray Usher (see
page 12). Televison was in its
infancy in those days but soon
children were to become fascinated
by futuristic characters from
Supercar, 1961, *Fireball XL5*,
1962, *Stingray*, 1964 and
Thunderbirds, 1965. (*Ray Usher*)

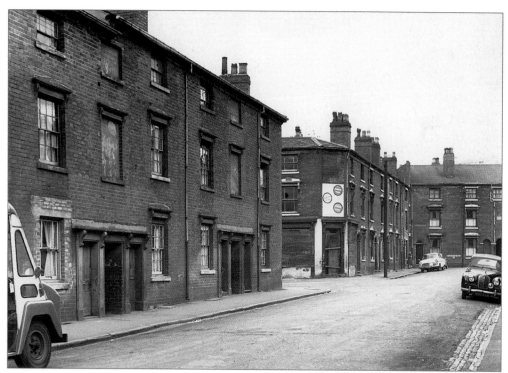

Garbett Street, 7 June 1967. Barker Street runs off to the left and, in the distance, Garbett Street joins Shakespeare Road.

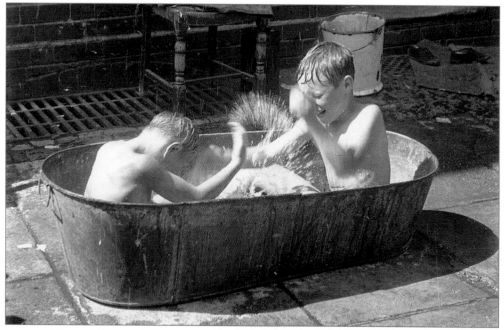

Peter and Tony Gilks, aged nine or ten, outside their home in King Edward's Terrace, St Mark's Street, 1964. Filling the bath was hard work especially if you didn't have a hosepipe; the bucket in the background was well used! (*Ingemar Lindahl*)

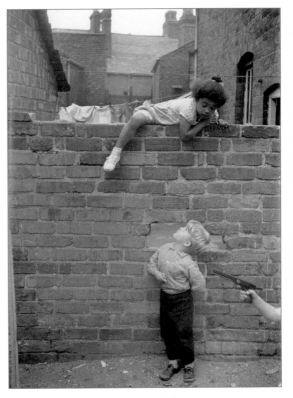

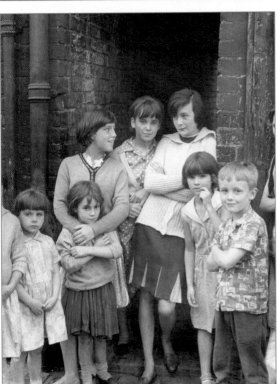

Swedish student Ingemar Lindahl took these photographs in 1964 while working on a project with Summerhill Methodist Church to create a children's playground. They were taken in and around Anderton Street and St Mark's Street, although the names of the people remain a mystery. The lad with a gun to his head looks suspiciously like the author of this book, although I can't be sure. If it is me then the man holding the gun could well be the publisher, making early attempts to encourage me to write this book! (*Ingemar Lindahl*)

Shakespeare Road as it looked on 21 April 1960. Most of these houses were built for the railway workers. Ironically the day this photograph was taken was the very day Dr Beeching was chosen to head the study into the future of the British Rail network, which ultimately destroyed so many livelihoods throughout the country. This view from Monument Road shows the boarded-up corner premises that once belonged to Lucy Lucas, a newsagent.

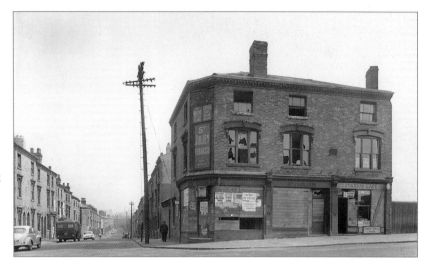

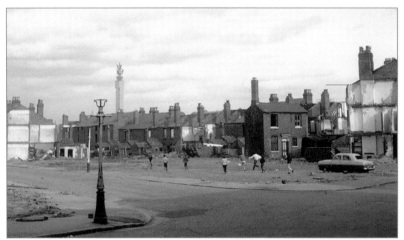

The remains of Anderton Street as viewed from Shakespeare Road during the clearance of the late 1960s. The GPO tower can be seen in the background. Ken Greaves once lived in a house near where the car is parked (see page 13). Before the comprehensive redevelopment Ladywood had 7,558 dwellings and only 3,609 afterwards. But there was much more open space, with 20 hectares compared to 0.8 hectares before. (*Ken Greaves*)

Late 1960s clearance, seen from Sheepcote Lane/Barker Street looking towards the remains of Nelson Street with Garbett Street behind. A new block of flats, probably Canterbury Tower, is being constructed in the background. The tower block, with electric under-floor heating, was completed in 1967. (*Ken Greaves*)

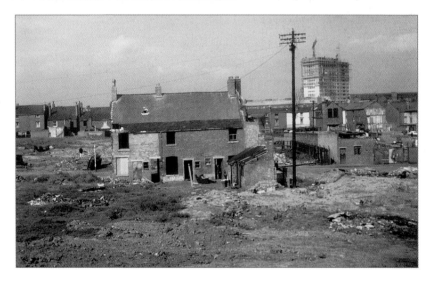

Alice Evans aged nine months in her grandparents' back garden at 97 Nelson Street, 1939.

A house at the rear of the Albion pub on Sheepcote Street. This is now the site of trendy upmarket housing.

Ethel Smith and her daughter Daisy Carter in Sheepcote Lane, 1948. Ethel lived in the same house, 5 Sheepcote Lane, for fifty years. The building in the background is the Gothic Works, former home of Glover and Main (see page 54). On the right stands a much-used cast-iron public urinal. (*Irene Smith, née Carter*)

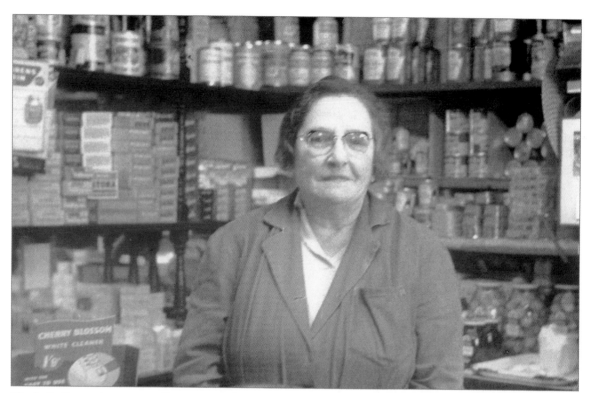

Elizabeth Evans, known to all as Bess, in her general store at 100 Nelson Street, *c.* 1960. Cherry Blossom white cleaner is on sale at 1*s* 9*d*. (*Jo Randle*)

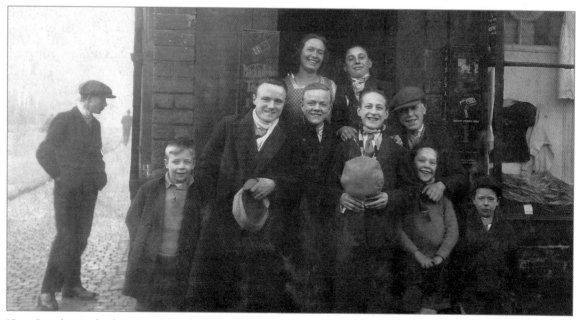

'Our Gang' outside the second-hand shop on the corner of Nelson Street and Barker Street. The chap on the left who is holding his cap is a member of the Goddard family, possibly Billy. Nelson Street linked Barker Street with King Edward's Road and Sandpits. (*Jo Randle*)

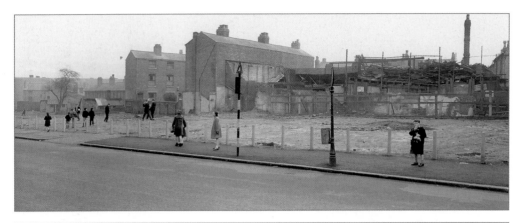

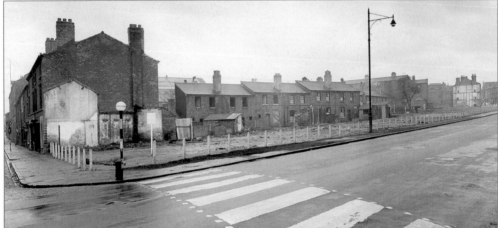

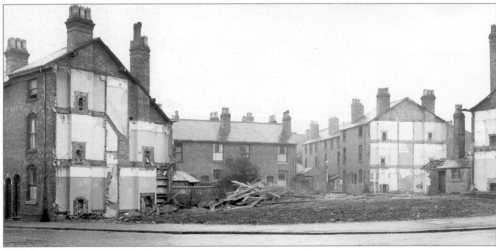

These three views of Monument Road were taken in November 1960. The lone schoolboy may well be humming Roy Orbison's 'Only the Lonely' which had just been replaced at the top of the hit parade by another appropriately named tune, 'It's Now Or Never', something that the planners had been singing for quite a while! Maybe the little lad was not in the mood for singing, knowing as he did that the world he was growing up in was changing so fast.

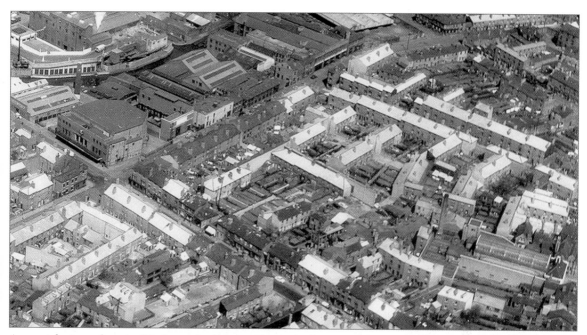

An aerial view of part of Ladywood, showing the typical terraced houses backing on to the factories. The near rectangular block, known as Icknield Square, is off to the right with Beach Street and Freeth Street running through the area. The Crown cinema is dominant on the left of the picture. Freeth Street now forms the boundary of the grounds of Ladywood Arts & Leisure Centre, formerly Ladywood School. All of the factories have either been demolished or are derelict and await demolition ahead of a major regeneration programme to start in the next few years.

Stan Jones with his toy car outside his house in Leach Street, *c.* 1950. Leach Street was one of the streets that ran off Freeth Street and can be seen on the aerial view. Clearly there was not a lot of space around in which to practise becoming Stirling Moss. He won his first grand prix in 1955, that's Mr Moss not Stan! (*Stan Jones*)

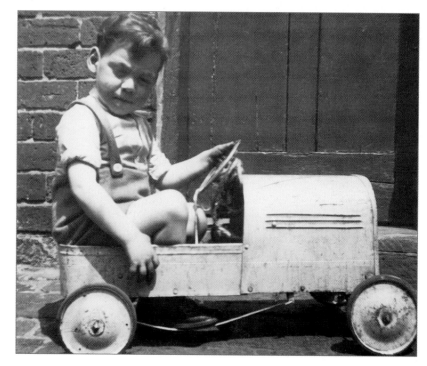

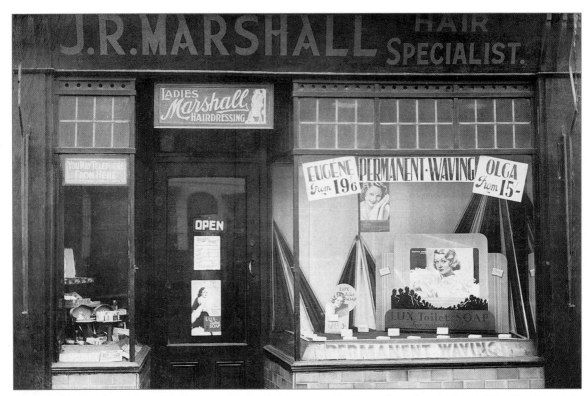

J. Marshall's hairdressers at 356 Monument Road, just a comb's throw from Leach Street. The Olga hairstyle was a snip at 15*s* and the Eugene 19*s* 6*d*. (*Jeff Pattison*)

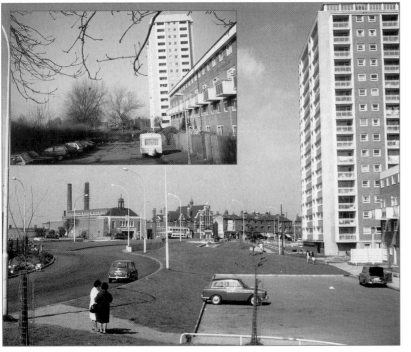

The buildings that survived the initial 1960s demolition on Monument Road. By the time this photograph had been taken in about 1972 the road itself had been carved up to become part of Ladywood Middleway. The bus is travelling along it outside the former Ladywood Community Centre, originally the dispensary. Planners went to great lengths to keep the building next door, the swimming baths, although it was demolished in 1994. The tower block on the redeveloped side of the road is Wells Tower. Inset: The same view today. (*Ken Greaves*)

Len Thornton stands to attention at the rear of his house in Friston Street where he was born in 1919. He says, 'Police Sergeant Brown of Ladywood Police lived in the front house so we had to behave ourselves!' As well as a policeman's helmet, he is wearing his grandfather's medals from the First World War. He adds, 'We moved out to a new council house in Weoley Castle in 1933. Mom had been trying for years to get more accommodation; six of us in a little house was too much, but this was normal in those days. The new house had everything this one had not got, such as three bedrooms, big windows, nice kitchen, a huge garden and best of all a bathroom and flush toilet all of our own. Sheer luxury!' (*Len Thornton*)

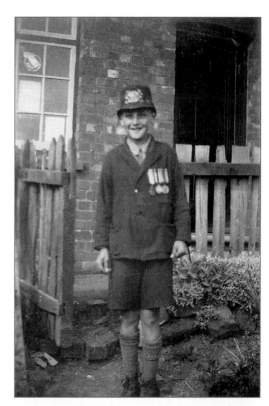

Above: Sisters Jennifer and Margaret Bayliss, aged two and eight, who lived in Geelong Terrace, Friston Street, 1947. *Right:* Betty Hammon, Ida Day and Mary Hammon outside Arthur Terrace, Friston Street, 1924. Notice the homemade birdcage on the wall. A great photograph of the street appears on the next page. (*Jennifer Jackson, née Bayliss, Betty Rooke, née Hammon*)

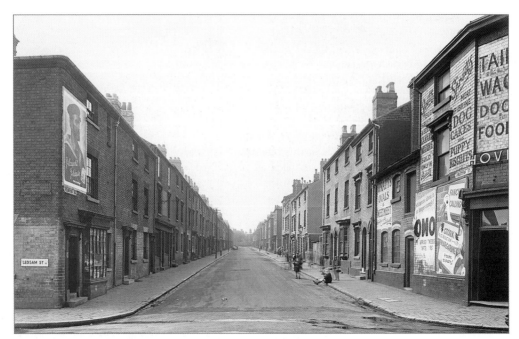

Friston Street from Ledsam Street, which puts everything into perspective! Friston Street disappeared in the redevelopment, and today the site is a grassy area behind St John's School. The name lives on in Friston Avenue, built nearby. Notice the all too familiar advertisements painted and posted on the end walls where they attracted maximum attention from passers by.

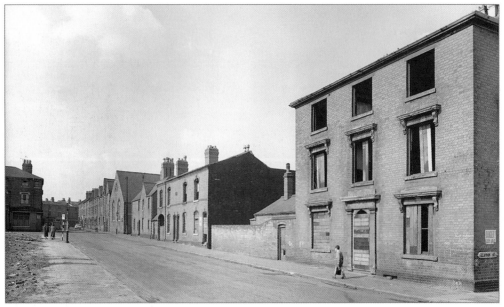

Johnstone Street, 20 April 1960. This was the week Aston Villa beat Rotherham United to clinch the Second Division Championship. The street is not exactly full of celebrating fans; perhaps they were in doors saving their pennies for the trip to the Tulip Festival in Cannon Hill Park, which opened the following week! Johnstone Street disappeared in the 1960s redevelopment.

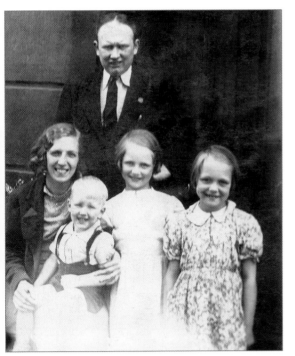

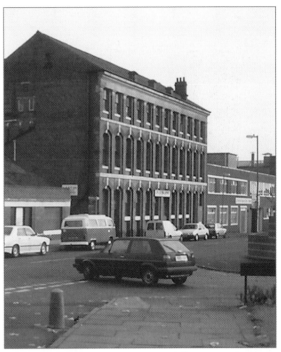

Jim and Lillian Labban with family members Jimmy, Margaret and Jessie, outside 201 Ledsam Street, *c.* 1938. Lily was a barmaid at the Nags Head and Jim was a metal polisher. (*Margaret Plummer*)

Industrial buildings in Great Tindal Street, November 1992.

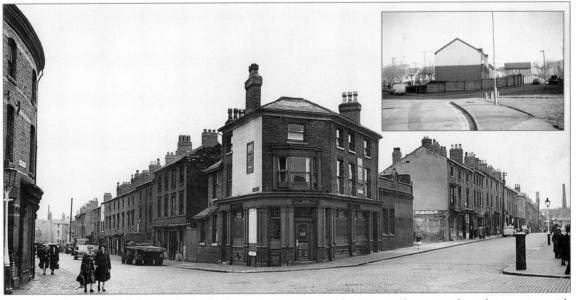

Great Tindal Street, 16 July 1954. The building in the centre is the Mount Pleasant pub at the junction with Ledsam Street which runs off to the right. Locals were no doubt raising a glass to the end of meat rationing and discussing such diverse newsworthy topics as a new radio programme called *Hancock's Half Hour*, Lester Piggott becoming the youngest ever jockey to win the Derby and myxomatosis. Inset: the same view today.

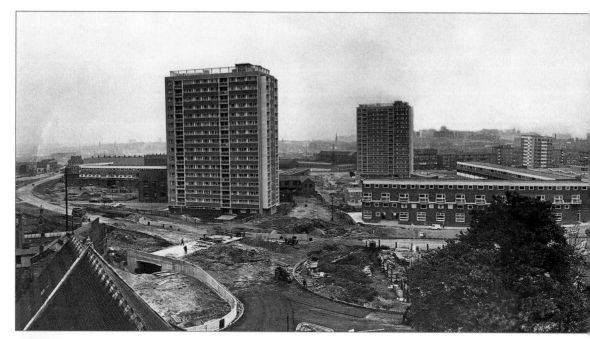

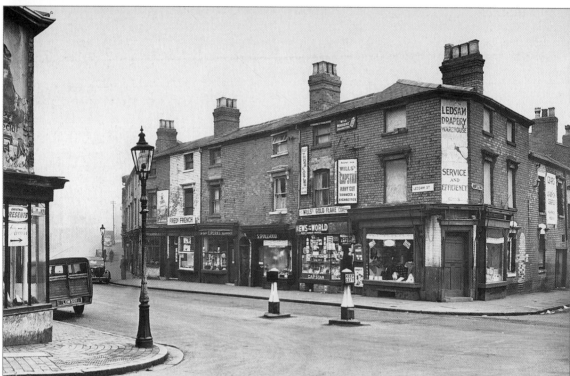

Most people remember Ledsam Street as a straight road, but this is the little turn at the Ryland Street junction. Morville Street runs across to the left and right. The van parked by the corner shop is pointing towards Blythe Street and the Vesper Bell inn, which can be seen on page 133. Messrs Smallwood, Perks, French and Ardley (?) ran the shops next to the newsagent. (*Johnny Landon*)

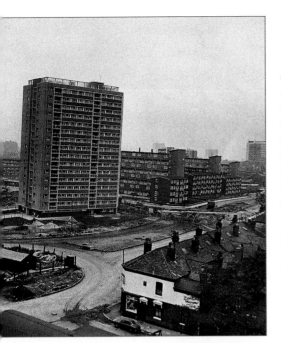

This great view of Ladywood during the redevelopment was taken from the top St John's Church tower in October 1965. The great planning disaster in the making, officially known as the Ladywood Middleway, slices its way through the area and one of the appalling pedestrian underpasses can be seen on the left near the church roof. The blocks of flats are Wells, Truro and Brecon Towers. In the lower right the last remaining houses on Wood Street and Alston Street await the bulldozer. Tall buildings were suddenly all the rage: this was the month the tallest block of flats in the city, at Lee Bank, was opened, and Princess Margaret found her prints when she officially opened the new HQ of the Birmingham Post & Mail in Colmore Circus.

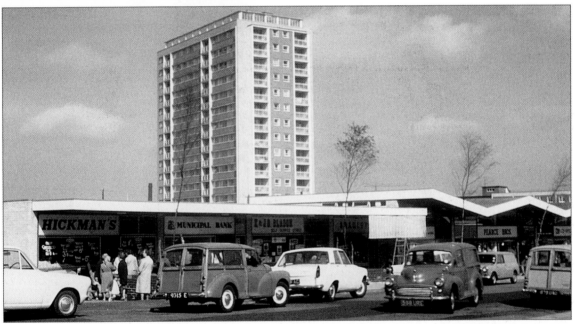

The new St Vincent Street shopping parade as it looked in the late 1960s. This new type of parade replaced the idea of traditional corner shops. I'm not sure if there is a collective noun for a group of headscarf-wearing women, but there is a bunch, gaggle or huddle of such people standing outside Hickman's greengrocery shop. Next door is a branch of the Municipal Bank, which replaced the one near the swimming baths, meaning you didn't have to go to great lengths to get to a bank. Next door is Pearce Bros, which moved from Ledsam Street corner near the Bridge Inn. Gupwells' watch shop is at the other end, as is the hairdresser, called Frankie's. Frankie's may be a hairdresser but it is definitely not a hair today gone tomorrow type shop, as it is still trading at this spot. Brecon Tower is in the background. (*Ken Greaves*)

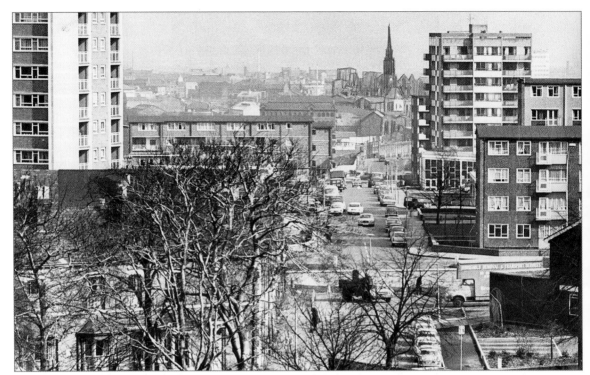

St Vincent Street West, 1972. The shops on the previous page are hidden at the base of the tower block on the left. Since then the area has undergone another redevelopment and the maisonettes on the right, part of the Gilby Road Estate, have been demolished and replaced by houses. The block of flats in the distance on the right, called Blythe House and named after Blythe Street, has also been demolished in recent years. St John's School is hidden from view behind the first maisonette block. The last remaining houses on Ladywood Road can just be seen behind the trees. (*Phil Waldren*)

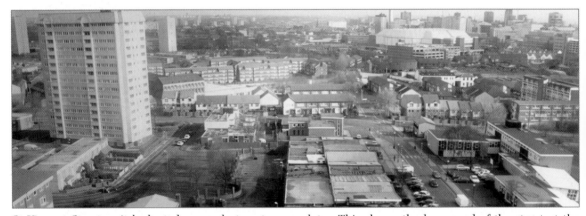

St Vincent Street as it looks today, nearly twenty years later. This shows the lower end of the street at the junction of what is left of Ledsam Street. Ledsam Street runs to the left, although it once extended across the junction. The route it took is now marked out by a walkway in front of the new houses on the lower right part of the photograph. St Vincent Street West runs down the centre of the photograph and becomes a walkway at the grassy area before reappearing in its original form to link up in the distance with Great Tindal Street heading off to Sheepcote Street. The National Indoor Arena for sport, which was opened in 1991, on the site of the former railway marshalling yards, dominates the skyline.

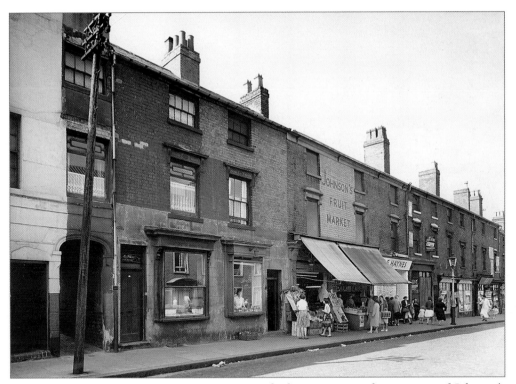

Ryland Street, 30 August 1961. Customers jostle for position at the premises of Johnson's fruiterers and Haynes butchers.

Donald Grogan outside his home in Ryland Street with his mate Bill Starkey, 1947. (*Bill Starkey*)

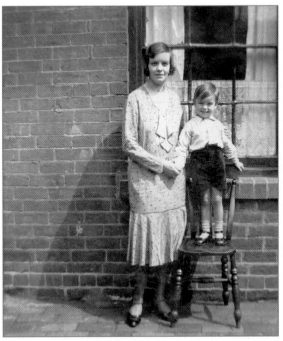

Nellie Teckoe and son Raymond in Essington Street, *c.* 1931. (*Sue Teckoe*)

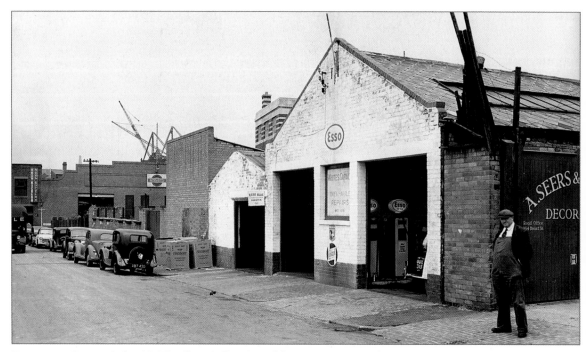

Essington Street, July 1955. The Midland Red bus garage on Sheepcote Street can be seen in the background. Opposite it, and partly hidden by the garage on Essington Street, is the imposing façade of the building belonging to the South Staffordshire Waterworks Co. Seer's decorators is on the right next to the Esso garage. This was the month that smoke control areas were created in the UK with the introduction of the Clear Air Act.

Val Ling's mother Marjorie with cousin Joyce and neighbours Robert and Anne Taylor survey the redevelopment underway in Browning Street. The man at the bike is Val's father Joshua, a well-known local fisherman and pigeon fancier. Val, then aged ten, is pictured in the backyard of 3 Browning Street prior to moving into the new Everitt Close on the Gilby Road Estate. (Val Rutter, née Ling)

Outside the back of 62 Morville Street, *c*. 1954. Left to right: John Adams, aged ten, Elizabeth Adams, who worked at W.H. Wilmot in Albion Street, Edna Adams and Barbara Pennicott, who was visiting from her home in Cope Street. (*John Green*)

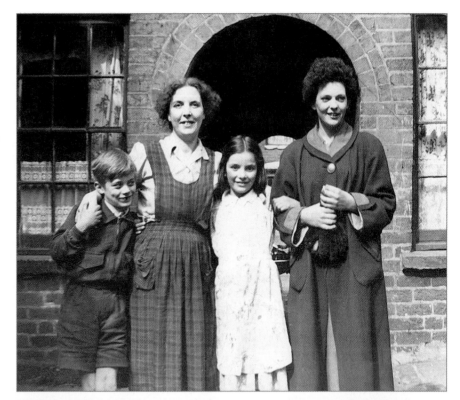

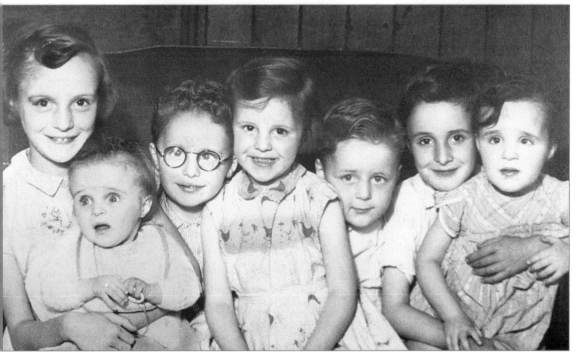

Seven of the thirteen children in the Ryan family at the back of 23 Ruston Street in 1959. Left to right: Norah, Bernie, Jerry, Margaret, John, Jim and Catherine. (*Bernie Stringfellow, née Ryan*)

Matthew (Mac) Norton of Rann Street poses for a
photograph in 1933, while Phil Trentham (right)
tries out his new tricycle. (*Mac Norton, Phil Trentham*)

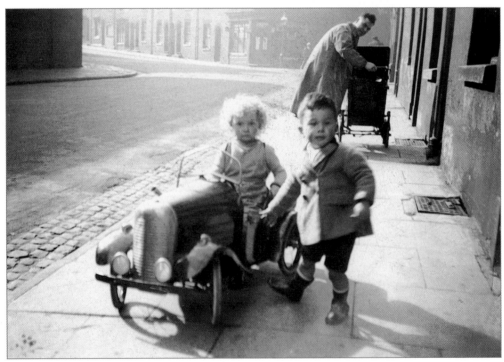

Phil Trentham progressed from the pram to this rather more stylish vehicle in 1938. He is
seen outside his home in Morville Street, with Sherborne Street disappearing into the distance.
His envious pal is David Hall, and Ernie Hall looks on in the background. (*Phil Trentham*)

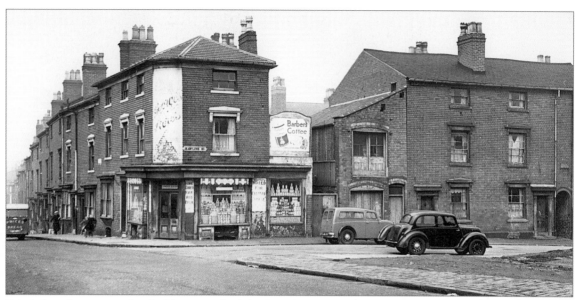

Price's bread van is sandwiched between the left edge of the photograph and the houses on Ladywood Road as it heads to the junction with Rawlins Street. The traditional corner shop, George's Stores, seems to be selling everything that anyone could possibly want including 'Home Cured Ham & Bacon'. The shop reminded people it was 'Noted for Cheddar Cheese'. The parked cars are facing Ruston Street North. (*Johnny Landon*)

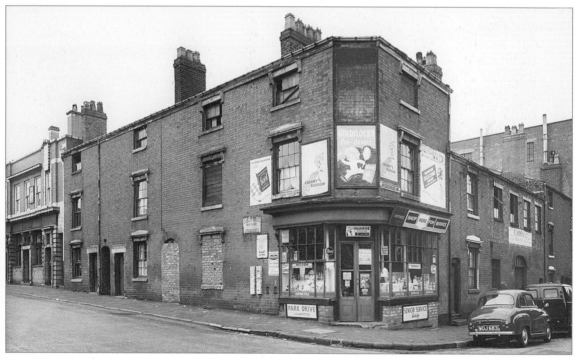

Sherborne Street and Grosvenor Street West, August 1961. The White Swan pub is on the extreme left. It is still open today, although it has recently been renamed Darwin's. Mr Whitehouse owned the corner shop. A couple of adverts that stand out are for Seel's polish and Goldilock's pan cleaners. E.C. Hopkins's premises are on the far right by the cars. (*Johnny Landon*)

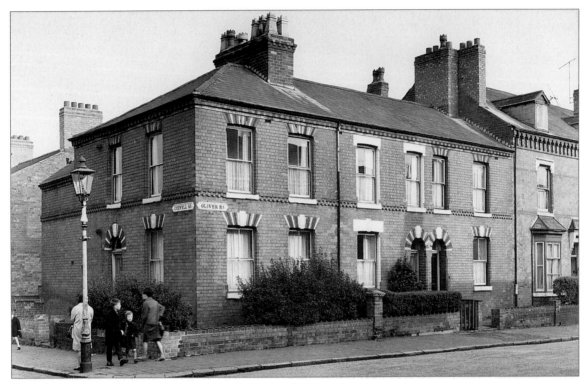

The corner of Oliver Road and Coxwell Road, October 1965.

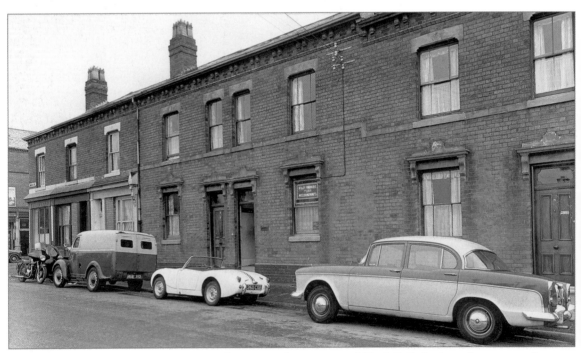

Wood Street, August 1961. An M&B outdoor is on the corner and H. & F. Parkes's turf accountant's seems almost disguised in the middle of this row of houses. St Vincent Street is at the end of the road. (*Johnny Landon*)

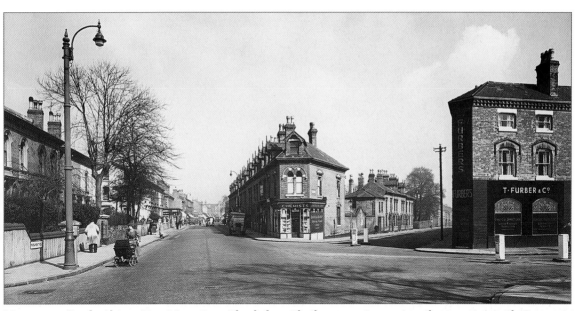

Monument Road, Alston Street junction. The lady with the pram is nearing the junction with Reservoir Road. Ladywood Road goes past Furber's the undertakers on the right, and the road that goes off at an angle is Alston Street, where the branch of Bannister & Thatcher's chemist is the dominant building.

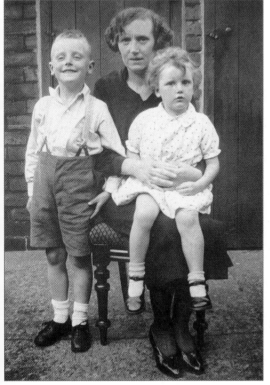

Mrs White with Derek and Joan in Harold Road, *c. 1935. (Barbara Edmunds, née Mitchell)*

Twenty-one-year-old Margaret Labban (see page 25), with Mary Plummer, Fred Gauder and Jessie Labban outside Jessie's house in Noel Road, 1953. *(Margaret Plummer)*

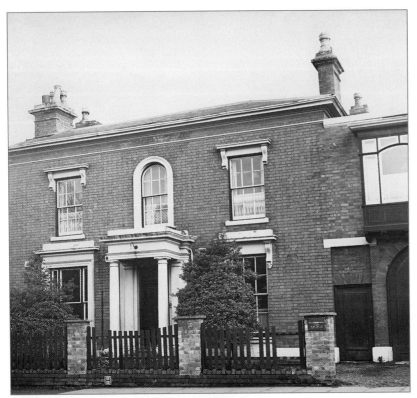

This large house at 266 Monument Road is typical of the type of rather more upmarket homes that lined both sides of the road on the approach to the Hagley Road at the Ivy Bush. Those on the pub side of the road were mainly replaced by blocks of flats, whose only grandeur lies in their names; Balfour House, Beale House and Clayton House, named after prominent worthy citizens. Many of the homes on the Noel Road side of the road still remain, including this one. Geoffrey Inshaw recalls, 'This was known as Nelson House and it was a popular dance school, run by Mr Knight, who was a judge on *Come Dancing*. (*Geoffrey Inshaw*)

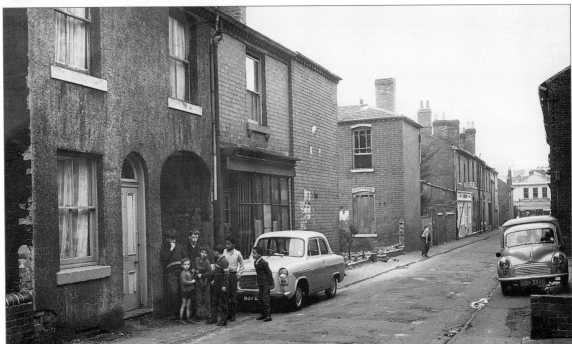

Bellis Street, August 1969. It looks peaceful here, but the children were no doubt talking about the disturbing television news pictures showing troops moving on to the streets of Northern Ireland. (*Johnny Landon*)

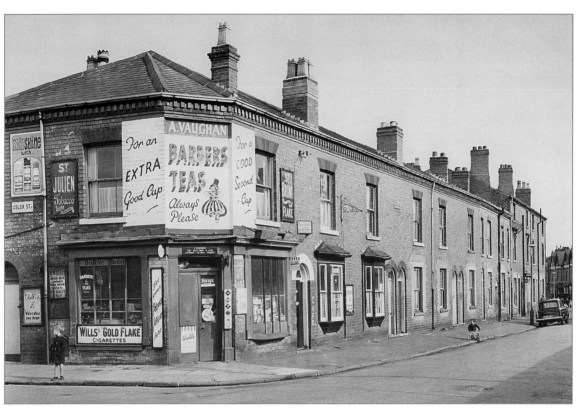

Reservoir Road, March 1968. This too is a peaceful scene, but across the world the US Army was reeling from attacks in the Vietnam War. Meanwhile 'In The Year 2525' reached number one in the charts. How many people in those shops could have even begun to imagine how the area would change in the next few years, let alone by the year 2525?

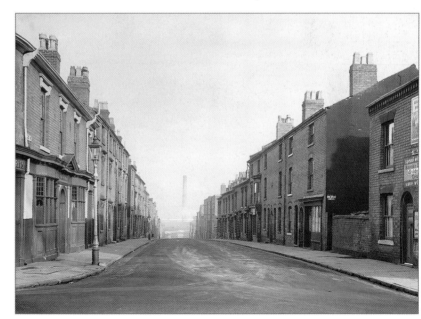

Osler Street, January 1952. The hill looks rather steeper than it really is, although it could be said the decline of Osler Street, and dozens like it, began this month when the corporation approved a twenty-year redevelopment plan for the city; under the guidance of city engineer Mr Herbert Manzoni £44 million was earmarked to be spent in the first five years.

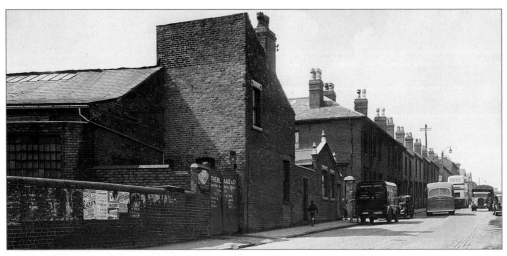

Icknield Port Road, looking towards Dudley Road, May 1951. Strips of tarmac run down the middle of the cobbled road where the tram tracks used to be. Although trams were still running in other parts of Birmingham at this time, the Number 33 tram route was taken over by the 95 bus in 1947, later renumbered 66. The single-decker coach behind the bus was from Dalton's Garage. The building behind the Laboratory Supplies van belonged to Litherland & Co., scrap metal merchants.

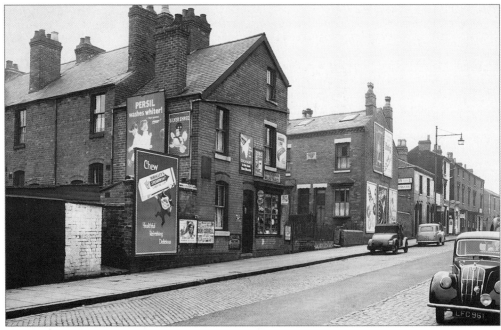

MacMahon's shop, 128 Icknield Port Road, April 1956. *A Town Like Alice* is the film being advertised on the wall; next to it is a poster for Don Cornell who was appearing at the Hippodrome. He was one of the best-known big band singers of his generation with twelve gold records between 1950 and 1962. According to the large advert on the wall Wrigley's chewing gum is 'Healthful, Refreshing and Delicious'; the advert fails to mention the mess it makes on the pavement, although in those days it was less of a problem than it is now. Planners were chewing over ideas to demolish these buildings on Lillie Terrace and Kenilworth Place.

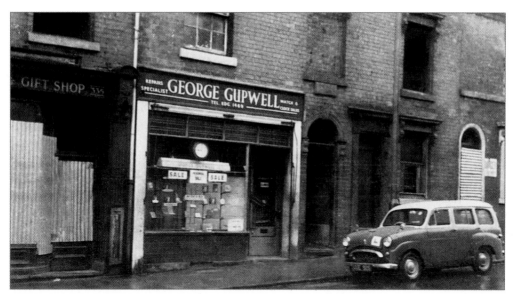

This was taken during the final week of trading at George Gupwell's watch repairers, 336 Icknield Port Road, September 1965. This was George Gupwell's second shop in the area; his first was on Monument Road, but during redevelopment he moved into these temporary premises, taking with him many of his loyal customers. Time stood still for a while because he stayed in this so-called temporary accommodation for nearly four years, before moving into the new shopping parade in St Vincent Street, seen on page 27. George Gupwell was clearly a man who moved with the times! (*Frank Hickin*)

George and Mrs Cooper with son Bob at home, 266 Monument Road. George was an enamel artist for Fattorini's and in his spare time was a well-known artist. This was a publicity photograph taken by the BBC because the Coopers' house was featured on the TV programme *Your Place* hosted by Barry Bucknall, the pioneering DIY presenter. (*Geoffrey Inshaw*)

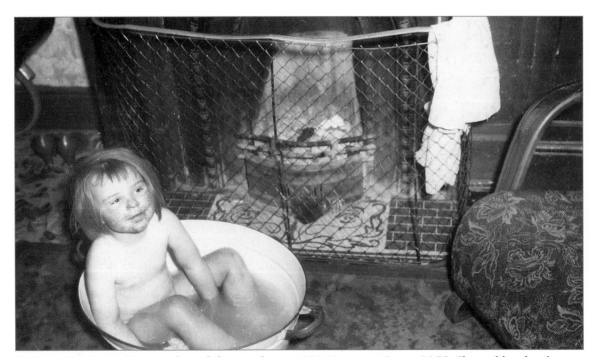

Bath time for Denise Hammond, aged three or four, at 113 Marroway Street, 1955. She and her family were living in the front room of their grandparents' house at the time as finding somewhere to live was rather difficult in those days. (*Frank Hickin*)

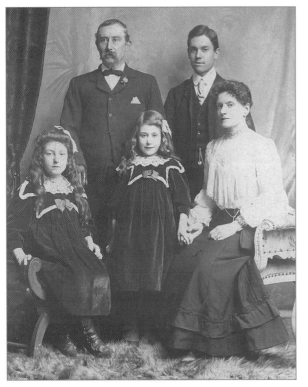

Shirley Hickin recalls: 'This family group was taken in about 1898 and the younger man on the back row is my grandfather, Frank Welch with his parents and sisters. They lived in Bristol before moving on to Bellefield Avenue. I remember him telling me how he joined a circus and became a trapeze artist, then during the First World War he was a soldier on a ship going through the Suez Canal when the ship began to sink. Fortunately they were rescued and continued to their destination. He was a bandsman in the Dorset Regiment and could play the violin and clarinet, I was given it when he died. He became a bus driver [see page 61]. He used to make toys for children. I had a beautiful push-along butterfly that flapped its wings and my sister had a wooden horse that she learned to walk with. He was interested in opera and he told me about characters in *La Bohème*, but my favourite story was the story of a toymaker who had a life-size doll called Coppelia. Grandad had a very interesting life and lived to be ninety years of age. He died in November 1969. It is books like this that help to keep his memory alive.' (*Shirley Hickin*)

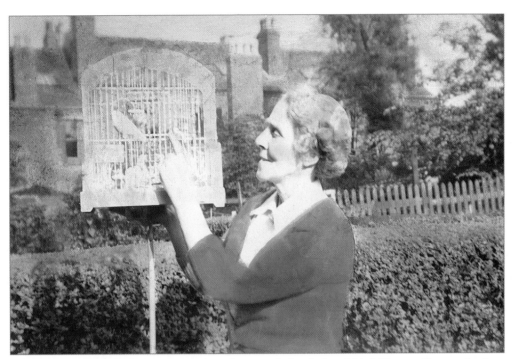

Nan Welch in Bellefield Avenue, 1950s. She is with her beloved bird Kimmy. He was the love of her life and was a great talker. (*Shirley Hickin*)

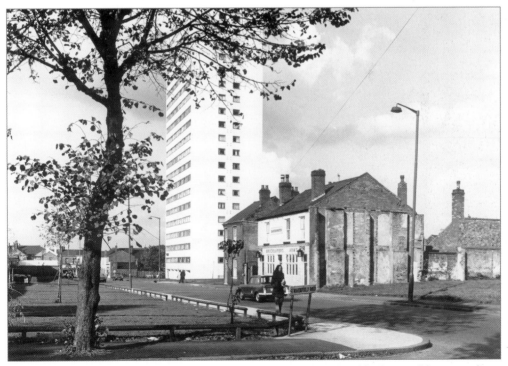

Icknield Port Road showing Flint Tower, October 1973. This block was blown up by a controlled explosion in February 2004.

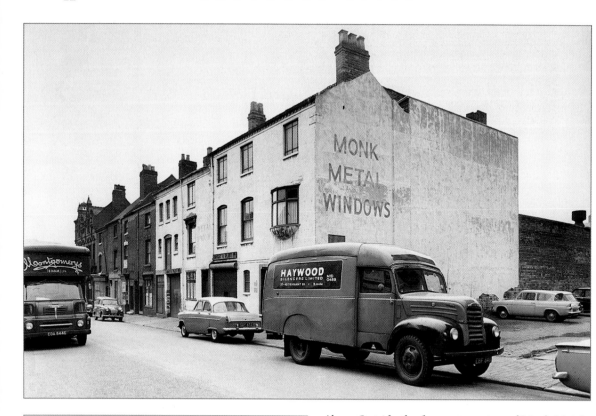

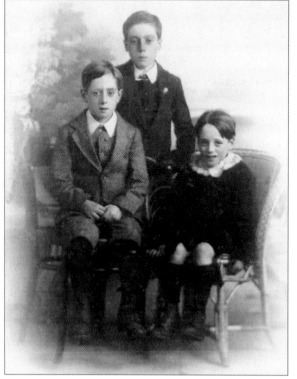

Above: Outside the former premises of Monk Metal Windows, Bishopsgate Street, April 1967. Haywood's made silencers and the van had travelled round from Tennant Street. The car behind the van is outside a sign indicating the current occupiers, Wright & Platt, model makers, who had occupied the spot since about 1961. (*Johnny Landon*)

Jon, Con and Mick Curley in Bishopsgate Street, pre-1920s. Jon, born is 1907, is David Curley's dad; Con and Mick are Jon's brothers. They lived in Bishopsgate Street at the time this photograph was taken, and later moved to Ledsam Street. The Curleys ran the Red Lion pub for twelve years. (*David Curley*)

2

People at Work

Bill Chadwick at McKechnie Bros machine shop, late 1940s.
(*Maurice Chadwick*)

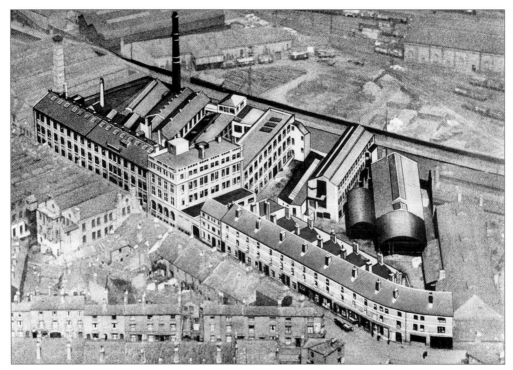

The premises of Belliss & Morcom are picked out on this aerial view of Ledsam Street, 1924. Great Tindal Street, with its densely packed terraced houses, runs along the bottom. The building on the curve in the bottom right-hand corner is what became known as the 'Dynamite Shop' following the discovery of explosives there in 1883. (*Phil Waldren*)

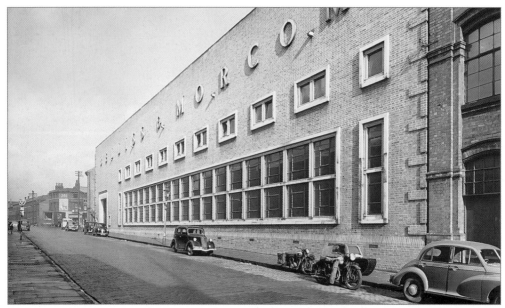

An extension to Belliss & Morcom was built alongside the existing premises on Ledsam Street and stretched up to the junction with Monument Road. This photograph was taken in February 1957. In later years this building was taken over by Yarwood & Ingram. (*Johnny Landon*)

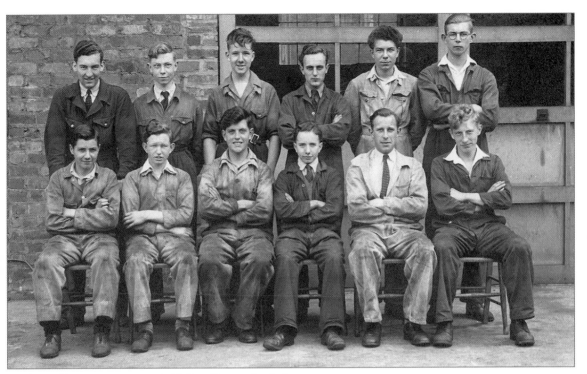

Staff at Belliss & Morcom, mid-1950s. (*Ernest Gordon*)

Belliss & Morcom apprentices, 1965. Those with a job for life included Dave Marsh, John Gibbon, Dave Parker, Arthur Simpkiss, Patrick Sharkey and Terry Parry. (*John Gibbons*)

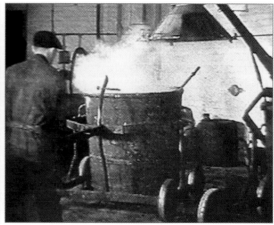

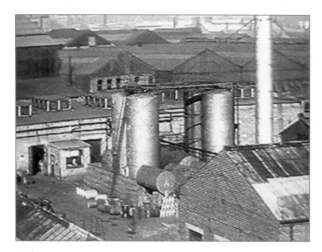

The original Docker Bros paint company was formed in 1881 and moved to Rotton Park Street in 1886. In more recent years it became Pinchin & Johnson, Courtaulds, International Paints and finally PPG, Pittsburgh Paint Glass. It was the decision of the US-based company to close the Ladywood site in 2003. These scenes are taken from a film made by the company in 1949, in the days when paint production, although extremely hazardous, was not subject to the stringent health and safety rules that exist today. (*Sonia Simmonds and Mark Barratt*)

W.T. French's of Browning Street was established in 1865. The company made electrical apparatus and once had premises in St Mary Street. Mysto sprayers, advertised by the Mysto Maid, were said to be the 'finest sprayers in the world'. In their 1950 catalogue the state-of-the-art table toaster was listed as being a self-turning double toaster, chromium plated and with moulded Bakelite. It cost 42s 6d. The electric percolator retailed at 55s and was of a 'pleasing design made of highly polished Aluminium'. 'The sound and well made iron' came complete with six feet of flexible cord and connector'. Yours for 20s. The building that housed the premises was demolished in November 2001 to make way for trendy canalside housing.

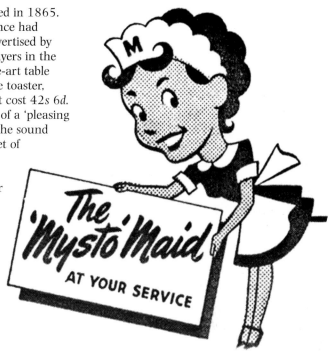

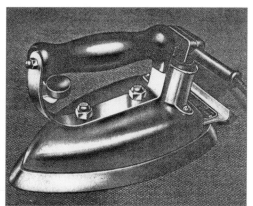

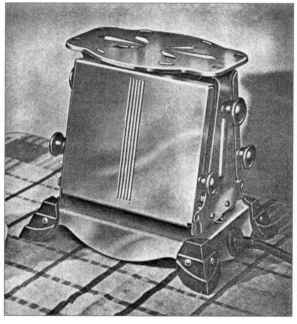

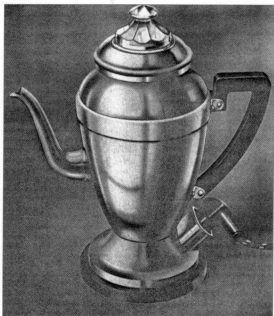

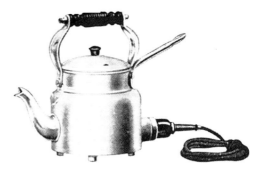

The poster indicates that Bulpitt & Sons was established in 1887 and their works on Camden Street, not far from Spring Hill library, was called Swansea Works. Bulpitt & Sons was associated with the manufacture of Swan brand kettles and pans. The name originates from a shortening of the word Swansea from where the tin plate was purchased. Bulpitt became the first manufacturer to immerse an electric element in water, thereby providing direct contact between the heat and the water itself, making kettles more efficient. In 1935 kettles cost 18s 6d each! Bulpitt's experimented with designs: they produced a combined kettle and saucepan, and in 1960 the first electric jug kettle was made.

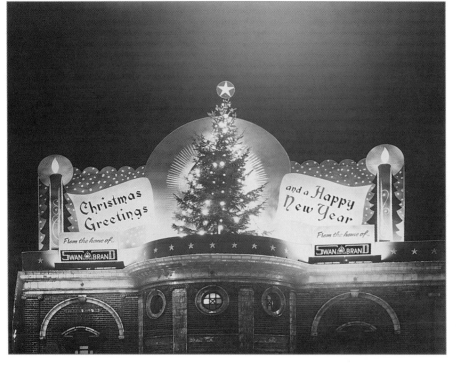

A Christmas greeting from Bulpitt & Sons. This was a tradition to which many people looked forward. The tree was on a prominent position on the corner of Summerhill and Icknield Street on part of the factory that was once the Palace cinema (see page 153).

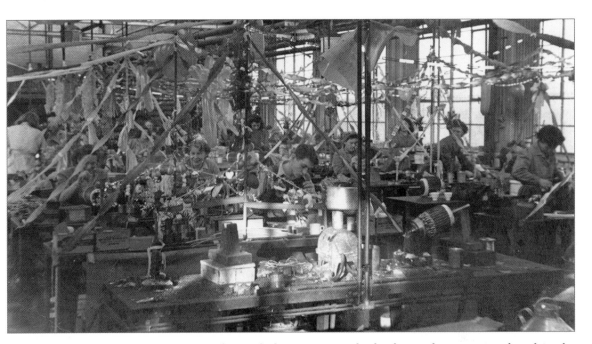

BKB Motors, owned by Bulpitt's, manufactured electric motors for kettles at their premises based in the Bulpitt's factory. These two scenes show work in production during the festive period in the early 1950s. Remarkable as it may seem, given today's health and safety standards, all the streamers were made out of paper! Barry Newbold says, 'The workers didn't seem to mind there was a casual easy-going atmosphere – as long as every one got their work done no one minded! The top picture shows an open burner on to which we placed an upturned saucepan to prevent the heat burning the decorations!' (*Barry Newbold*)

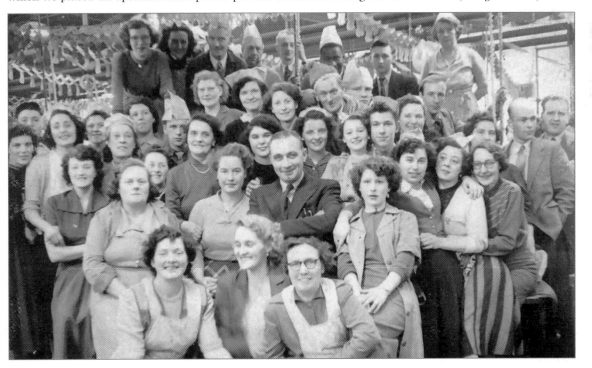

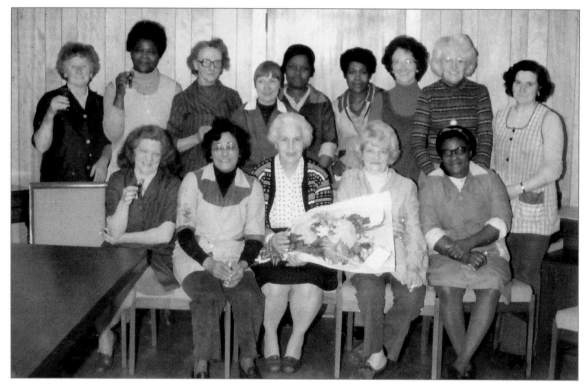

A presentation to mark the retirement of Ivy Gorse from Bulpitt & Sons, 1978. (*Terry Gorse*)

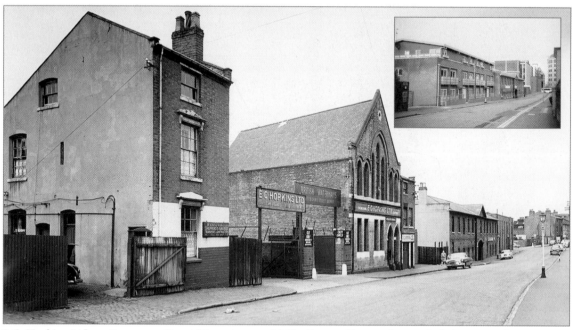

E.C. Hopkins Ltd on Grosvenor Street West, August 1961. George Elmer, who worked there, recalls, 'Hopkins' made flexible shaft machinery and grinders.' A residential block replaced E.C. Hopkins's factory. The mill still remains, although at the time of writing it is empty. Inset: the same scene today.

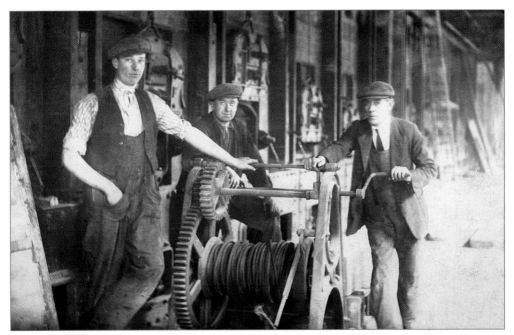

Winfield's Rolling Mills, Icknield Port Road, *c.* 1936. The man on the left is Charlie Wilkes who lived in Reservoir Terrace, Osler Street. (*Maurice Chadwick*)

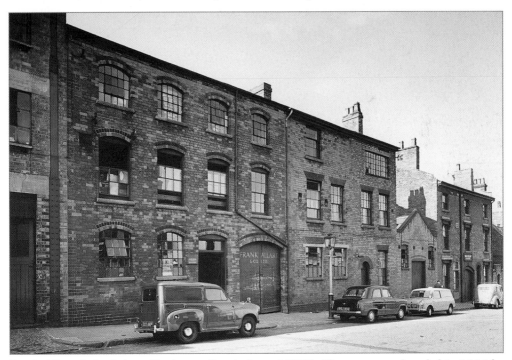

Frank Allart & Co. Ltd on Sherborne Street, August 1961. The company, founded in 1914 by George Allart, was a patternmaker's, but now specialises in brassware for the architectural, marine and railway trades. A new manufacturing plant was opened in nearby Great Tindal Street in 1995. (*Johnny Landon*)

The staff at Wiggins's canteen, on Icknield Port Road, take a break in the early 1950s. The dam wall holding back the reservoir is in the background. This is now the site of the Centennial Centre. (*Nora Bartlam, née Wilson*)

Wiggins's workers: Mr C. Kelly and Jimmy Smith. Mr Kelly was featured in the works' magazine after completing twenty-five years' service and Mr Smith retired after thirty-two years' service. The caption stated, 'He is going to run a pig and poultry farm with his brother when he leaves Wiggin Street.' (*Ron Kelly*)

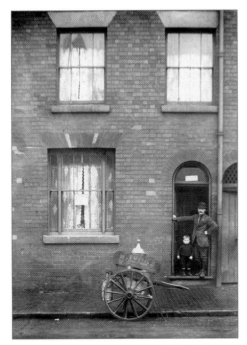

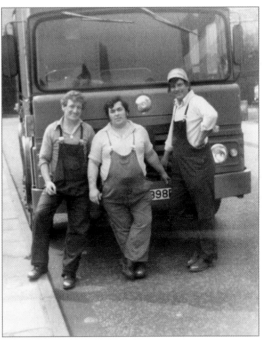

Dairyman William Tonks with his delivery cart outside his house at 31 Hyde Road, 1925. The child is four-year-old William Griffiths. (*Violet Clarke*)

'Scraggy', 'Cuddly' and 'Johno' Johnson take a tea break at the salvage depot off Rotton Park Street, *c.* 1980. (*Billy Codling*)

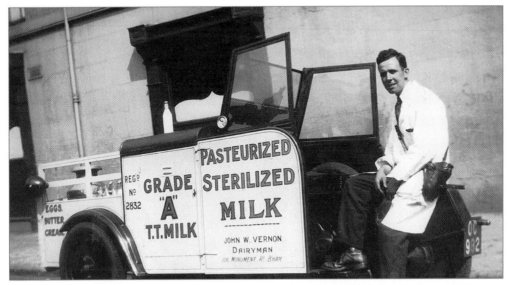

John Vernon, a dairyman of Monument Road, with his three-wheeled milk float. He lived at 106 and later 393 Monument Road. His nephew Vernon recalls, 'He worked on a milk round after leaving Osler Street School in 1921 and by about 1930, the assumed date of the photograph, he had set up his own round. He delivered milk across Ladywood for all his working life until his retirement in 1972. His three-wheeled vehicle was ultimately replaced with a series of Morris vans.' (*Vernon Millington*)

John Dickinson's stationery works is the dominant building at the junction of St Vincent Street, Sheepcote Lane and King Edward's Road in 1961. Previously the building, known as the Gothic Works, was home to Glover & Main, the well-known manufacturer of gas meters and stoves. The National Indoor Arena has since replaced the railway marshalling yards behind the new fence on the right. The houses on Sheepcote Lane can just be seen on the immediate left behind the wall. The wall is still standing today, although the cast-iron urinal at the end of it has now been removed and replaced by a well-watered bush!

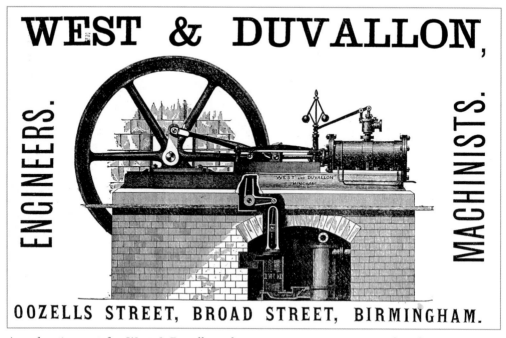

An advertisement for West & Duvallon, the engineering company, produced in 1876. The company was based on Oozells Street, a hive of industrial activity by the canal. Oozells Street is covered in more detail in my book *Broad Street, Birmingham*, Sutton Publishing, 2002.

Bellamy & Co. began life at the end of the twentieth century on Granville Street and developed across the generations to become a thriving garage on Clement Street, just opposite the National Indoor Arena. The business closed in April 2003 after being in the same family since the 1890s, when this photograph was taken. (*Charlie Bellamy*)

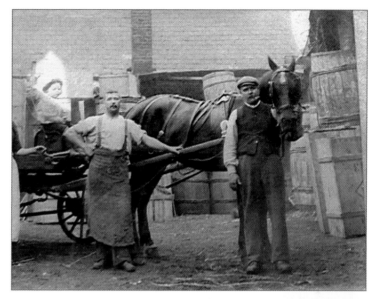

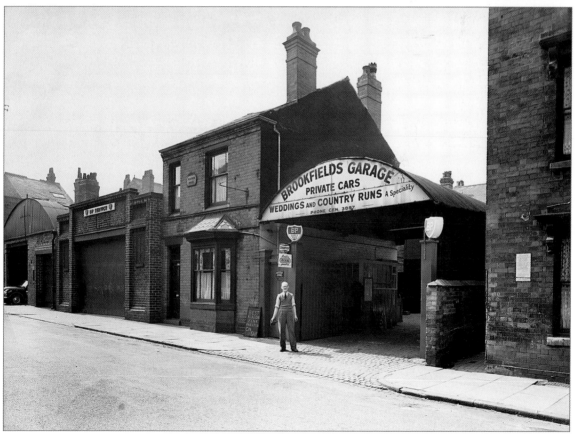

Brookfield's Garage on New Spring Street, June 1958. The advert reads, 'Brookfield's Garage: Private Cars, Weddings And Country Runs A Speciality.' The board on the pavement reads, 'Best Aladdin Pink Paraffin on Sale'. (*Johnny Landon*)

S.A. Daniell of the Lion Works on Edward Street near the junction with King Edward's Road. In 1911 their near neighbours included makers of planes, fenders, boots, hooks and eyes and a cooper, all industries that have long since died off. A 1901 advertisement states that the works won a silver medal at the Paris Exhibition the year before.

Below: Joseph Moore's of Pitsford Street, established in 1845, as it looked on an advertisement of 1911 that boasted of medals made in the 1850s.

Wacaden was a popular dairy well known for premises in Monument Road, between Noel Road and Waterworks Road, up until the mid-1950s. This 1953 advertisement indicates that the business was based in Nova Scotia Street in Aston. At the time Wacaden had around ten branches including ones in Farm Street, Hockley, and Moilliet Street, Winson Green.

Workers wait for their prints to come outside the Kodak factory on Icknield Port Road. Back row, left to right: Barbara Mitchell, Miss Paxton, Mrs Baynham, Barbara Smitten, Miss Orgill and Jean Henley. Front row: Iris Burgoine, Sheila Meakin and Betty Heavon. As was common in those days most of the workers lived just a short distance from work, Jean and Betty both lived in Bath Passage, off Monument Road. (*Barbara Edmonds*)

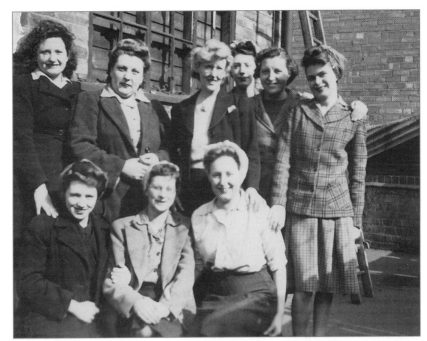

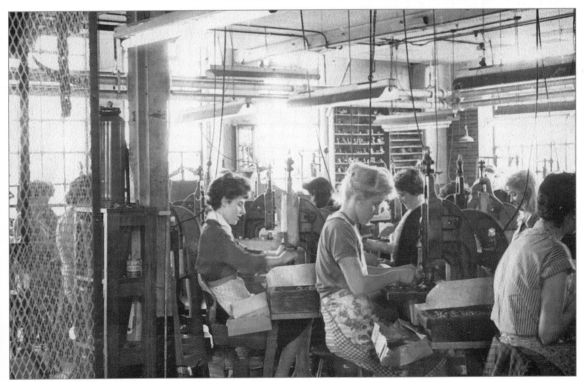

Gaunt's Badges, Warstone Lane, 1960. Shirley Hickin is in the centre and Margaret Biddle is on the immediate right. Shirley says, 'It made badges for holiday places and birthdays, etc. and also military uniform buttons. I remember doing some for Hastings Banda [former dictator of Malawi] and Claribell coaches. It was dirty and noisy but the people were a very friendly bunch.' (*Shirley Hickin*)

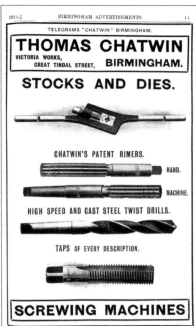

Two 1911 advertisements for Archdale's and Chatwin's. Chatwin's was established in the middle of the nineteenth century. It won awards in Calcutta (1884), Stockholm (1886), Adelaide (1887) and Melbourne (1888). Both firms were once a major source of employment in Ladywood. Archdale's had a factory in Ledsam Street and an iron foundry in Icknield Square. They eventually outgrew the Ladywood premises and in 1961 they moved to Blackpole in Worcestershire. A number of the workers moved out to continue working with the company.

The original building at The Mint, as it looked in 1860. The Icknield Street-based business was the world's longest-running privately owned mint, although cash flow problems in the late 1990s resulted in many redundancies, and, regrettably, closure came in 2003. The inset shows the building in November 2003 as it awaited conversion, probably into apartments.

This business based in Ryland Street may have been called Young's, but it was an old established company set up in 1856. It developed a range of metal goods to fit the needs of the day. In 1930, when this advertisement was produced, it manufactured items for tramways and omnibus garages. It was based next to the Hermatic Rubber factory and was still trading from there in the early 1960s.

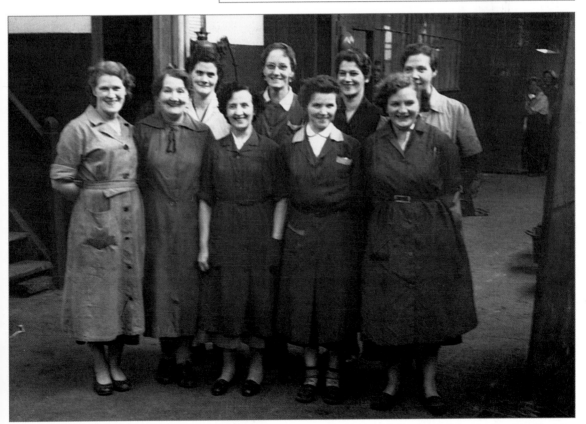

Women workers at McKechnie Brothers, off Icknield Port Road, 1940s. Nellie Chadwick who lived in Beatrice Terrace, Osler Street, is on the back row, second from the left. (*Maurice Chadwick*)

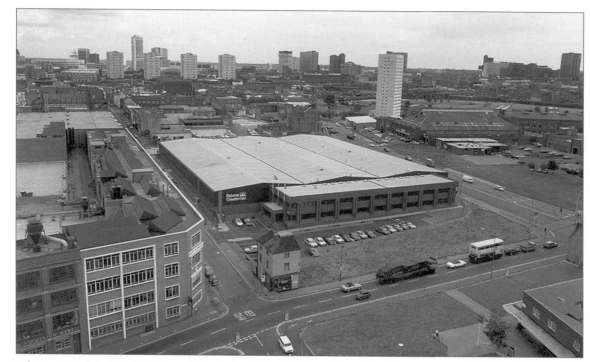

When most of the Bulpitt & Sons factory near Spring Hill was demolished this new building was erected to take its place. Part of Bulpitt's can be seen on the left. The newly built structure belonged to Rabone Chesterman's who moved there from Hockley. The isolated corner building belonged to a hairdresser who survived the surrounding demolition and stayed there for another few years until his lease ran out. (*Bernard Fagan*)

ALBION TUBE WORKS

*Rules and Regulations**

1 All hands employed at these Works shall before leaving give seven days' notice.

2 The whistle will be sounded at half-past eight, one o'clock, and five o'clock, and no one must leave his work to wash his hands, or boil water, or any other purpose, until the whistle sounds.

3 For fighting, using bad language, throwing, or larking, a fine of two shillings and sixpence, or he will be immediately discharged at the option of the Works Manager.

4 No machine to be cleaned while in motion.

5 Any workman disobeying the reasonable orders of the foremen or others in authority will be immediately dismissed.

6 Anyone smoking during working hours will be fined one shilling.

7 Any engineman not properly cleaning boilers or neglecting to oil shafting to prevent cutting will be fined two shillings.

8 All size pieces, gauges, and taps must be returned to their places properly cleaned by the person who used them last, or he will be fined sixpence.

9 Anyone being absent without just cause and thereby causing inconvenience and loss, will be fined two shillings.

10 Anyone found idling or away from his proper place of work will be fined sixpence.

11 As voluntarily agreed by the workmen, all hands employed are expected to join in the contributions to Hospital Saturday Collection, to the Sick Club, and also to the Benevolent Fund.

A list of fines will be stated each week, and the amount paid into the Sick Club fund or fine account.

By order,

LLOYD & LLOYD

(* *circa* 1870)

Lloyd & Lloyd's, later Stewart & Lloyd's, metal tube manufacturers, of Sheepcote Street issued these rules and regulations to the workforce, *c.* 1870.

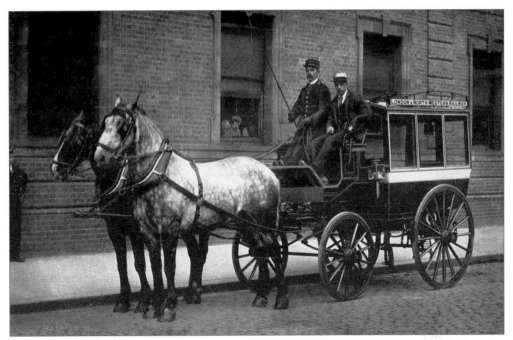

This 1905 postcard shows 'a family omnibus with rubber tyres' thought to be outside the stables at the junction of St Vincent Street and Sheepcote Street. It belonged to the London & North Western Railway Co. (*Edward Dunn*)

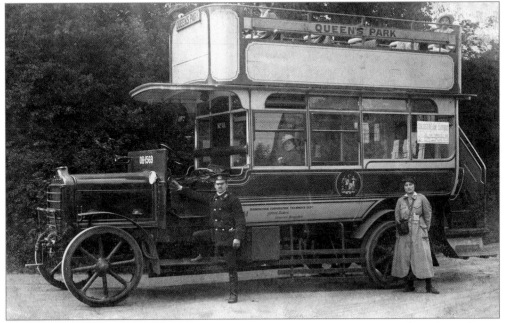

A Birmingham Corporation bus on the route from the city centre to Queen's Park, Harborne via Five Ways. Driver Frank Welch presumably drove his solid-tyred vehicle very carefully on this day, as his wife Dorothy was the top deck passenger! This was just the ticket for the unnamed conductress. (*Frank Hickin*)

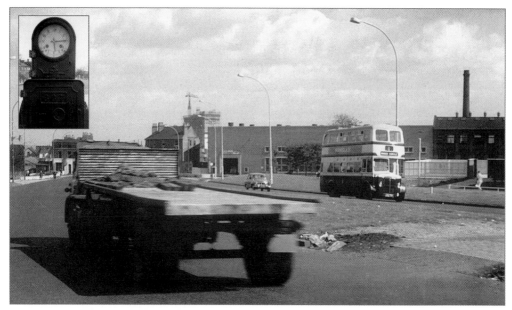

Ladywood Middleway, near to the junction with Ledsam Street shortly after it opened in 1972. The lorry has just passed the swimming baths, and the Inner Circle number 8 bus is approaching the spot where the Ladywood Methodist Church once stood, until it was replaced by a tree and expanse of grass. The factories in the background are on Ledsam Street. The inset shows the Bundy clock located at the stop where drivers used to 'clock in'. (*Ken Greaves*)

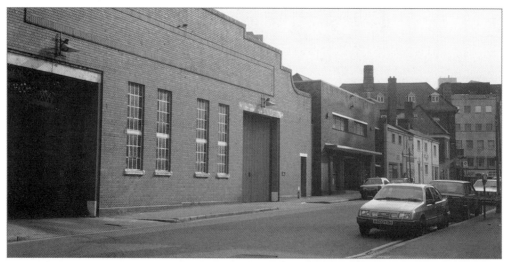

The former Midland Red bus garage, Sheepcote Street, October 1986. Midland Red, or the Birmingham & Midland Motor Omnibus Co., to give it its full title, occupied the site from August 1951 and the depot housed seventy buses, before it passed into the hands of the WMPTE in 1973. In 1932 a far-sighted plan was drawn up, but never implemented, for 'a huge' bus station on the site to provide 'the starting and stopping place for firms from all over the country', and it was to have included a hotel with 'accommodation for drivers of long distance charabancs and lorry drivers as well as ordinary passengers'. Today there is a hotel nearby, but the garage has disappeared and the street has been realigned to go through the site of the garage. The synagogue next to the garage is still in use.

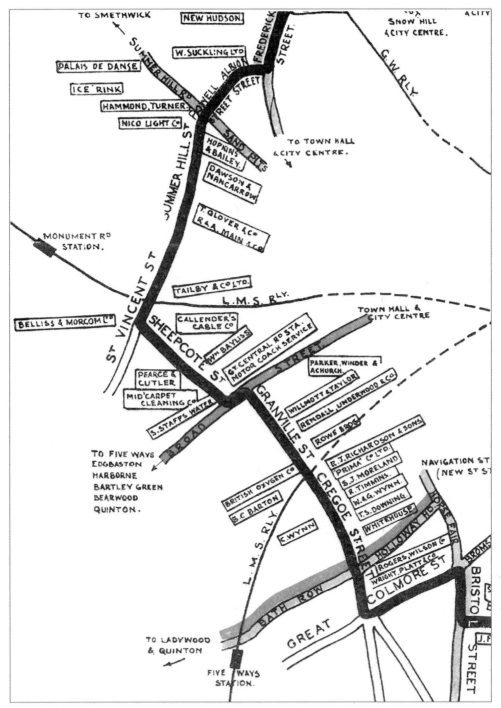

Part of the route plan for the City Circle bus route number 19 taken from a timetable leaflet of 1932. This was an extremely useful route as it linked many places of work in the industrial heartland of the city with the residential districts. The largest industrial concerns and places of leisure are marked on the map. Very few of them are still located at these sites today and the route itself no longer exists. (*Geoffrey Inshaw*)

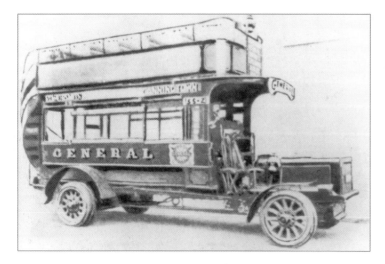

This was a prototype bus manufactured at Belliss & Morcom in 1908. It was never used in Birmingham, but may have graced the streets of London. (*John Gibbons*)

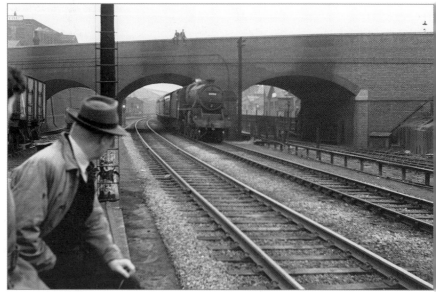

A southbound express passes under the St Vincent Street Bridge, *c.* 1950. This area is now beneath the National Indoor Arena. (*Roger Carpenter*)

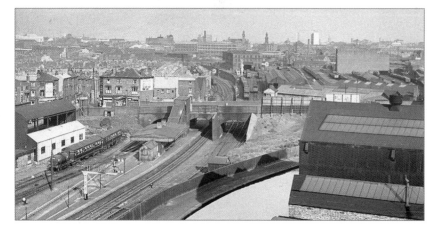

Monument Lane station, 8 July 1958. Monument Road runs across the middle of the photograph. The Everly Brothers reached number one in the hit parade that week with 'All I Have to Do is Dream'. Who could have dreamed that this area would change so quickly? (*Phil Waldren*)

3

Schools

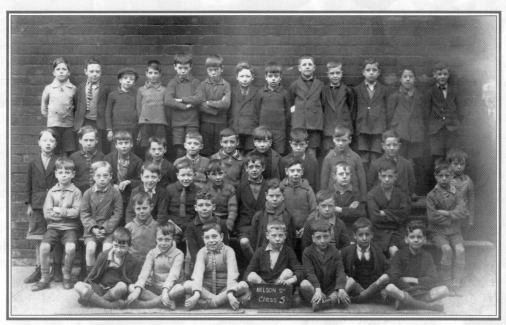

Class 5 at Nelson School, 1930. The lad on the front row with the long tie is
William Evans. (*Jo Randle*)

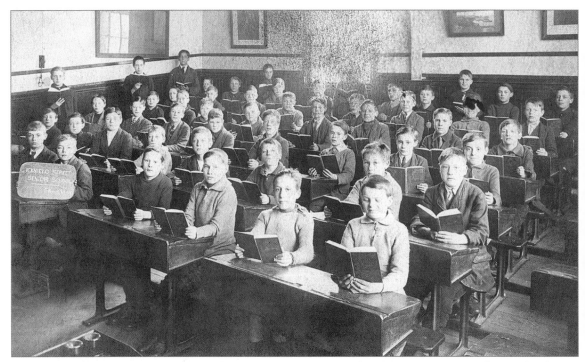

The handwritten note on this postcard states it is a class at Icknield Street Senior School. The date is unknown although the school was one of the first Board Schools to be opened in Birmingham in 1883. The school was designed in similar style to Steward Street, opened in 1873, and Osler Street, in 1875. The building still exists, although it is no longer a school.

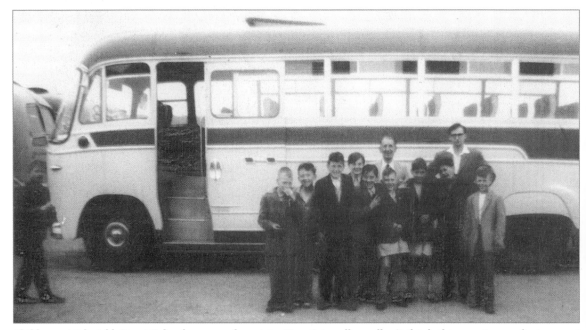

Children at Icknield Street School prepare for a trip. Ken Grinnell recalls, 'I think this was in our first year at the school in 1959. Some of my mates on it are Joey Wise, Alan Williams and Trevor Lewis.' (*Ken Grinnell*)

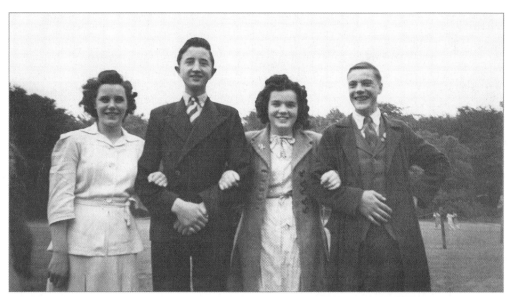

Children from the youth club at St Peter's RC School on Broad Street enjoy a day out at Oscott College, *c.* 1946. Left to right: Pat Fagan, Frank McVeigh, Nora Wilson, mother of the author of this book, and a friend called Bill. (*Nora Bartlam, née Wilson*)

St Peter's RC School headteacher Marjorie Clements wrote this letter to the head of Trescott School in Northfield in 1948 to thank the school for hosting a visit to the countryside for her inner-city pupils. Let's hope the children enjoyed it as much as she did! Pictured next to the letter is pupil David Cunnington in 1949. (*David Cunnington*)

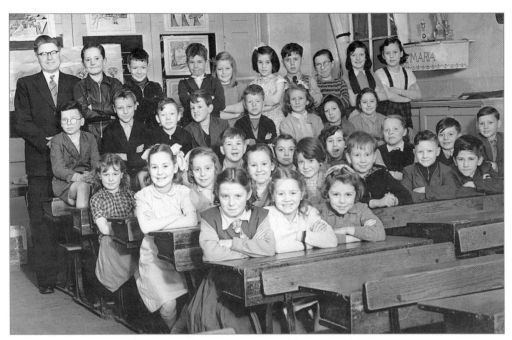

St Peter's RC School, Mr Padden's class, *c.* 1953. (*David Cunnington*)

St Peter's RC School, off Broad Street, 1959. The school was adjacent to the church and both were demolished and eventually replaced by the International Convention Centre. The five pupils are Paul Brownhill, Raymond Bolger, Raymond Smitheson (aged nine), Thomas Bailey and Gerald Burke. (*Mr Smitheson*)

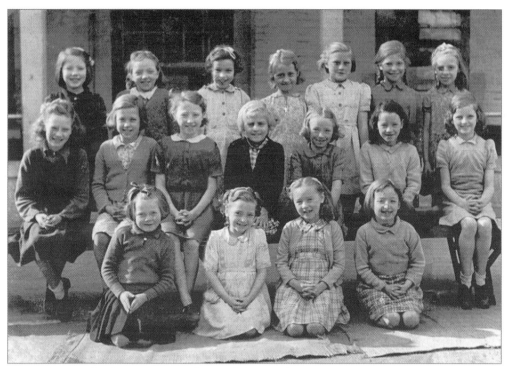

St Peter's RC School, 1946–7. Back row, left to right: Maureen Keenan, -?-, Joyce ?, Mary Wilkes, Eileen Fenton, Josie Draper, Sheila ?. Middle row: Rosemary ?, Shirley Ollis, Maureen McVeigh, -?-, Mary Wilsa, -?-, Susan Behan. Front row: Collette Smith, Pat McDermott, June Horton, Joan ?. (*P. Jervis*)

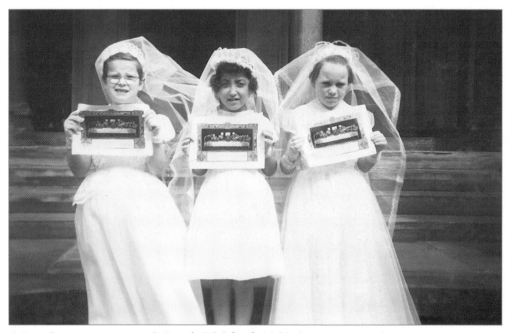

A First Communion trio at St Peter's RC School, 1957. (*Margaret Davies*)

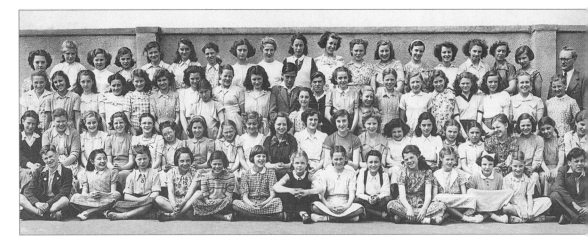

St Thomas's School Choir, 1952. Mavis Ridley recalls, 'This was taken from the roof of the school which was the senior playground. We used to sing at many venues, among them the Town Hall, and we did an audition for BBC Radio. Notice there are only four boys in the choir.' Some of the names she remembers are Miss Hancock (end of back row, left) and Mr Butler at the opposite end. Choir members include Eleanor Taylor, Joyce Lewis, Stella Cash, Margaret Roper, Ann Piper, Maureen Townsend, Beryl Taylor, Pat Jones, Jean Miller, Valerie Dowell, Pat Richards, and Sheila Kirby. Two of the boys are Ken Parkes and Bill Owen. (*Mavis Ridley, née Chare*)

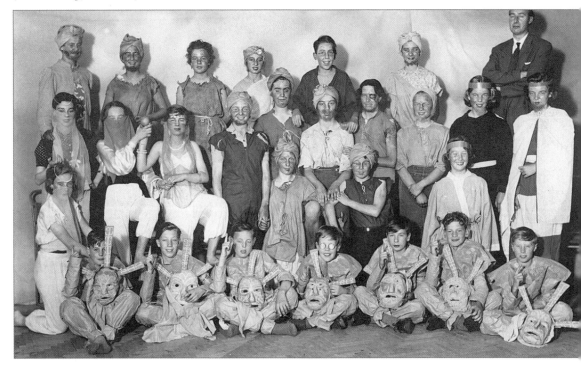

'Gods of the Mountain' performed by St Thomas's pupils in 1952 at the Emile Littler Theatre, Oozells Street/Broad Street. Maureen Shaw recalls, 'It was a great thrill to compete in this stage competition, quite an event for us all. The people who I remember are Doreen Marshall, Jean Millar, Ann Livesay, Bill Owen, Janet Garrett, Maureen Townsend, Doreen Honeybourne, Beryl Taylor and Frank Peake. Mr Smallwood is on the end of the back row; he worked very hard with us.' (*Maureen Shaw, née Townsend*)

The kitchen staff at Oratory
School, 1977. Left to right:
Janice ?, Mavis MacAdams,
Josie Coughlan, Marion Hanks,
Gert Price and Janet Venum.
Gert worked there for thirty
years and Josie is now the
head cook, but she doesn't
want to make a meal of it!
(*Josie Coughlan*)

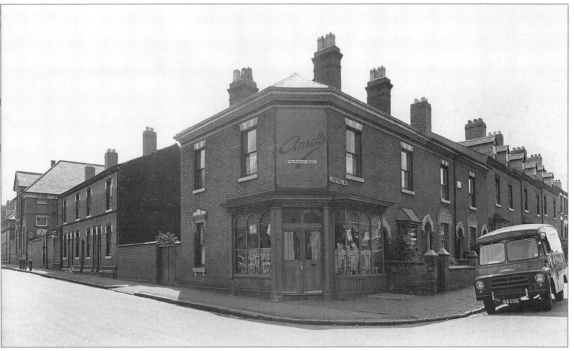

The Oratory School can be seen on the left of this photograph at the junction of Hyde Road and Coxwell
Road on 10 August 1961. This was the day that Britain formally applied for membership of the EEC. There
is a noticeable lack of rejoicing in the streets at this news, probably because most residents were on their
summer hols at Rhyl or Weston! The van outside the Outdoor has the slogan 'Kernel Bill's'. Does anyone
know what Kernel Bill sold? In the subsequent redevelopment these streets were removed and the current
Oratory School was built on this spot.

St Barnabas's School, Ryland Street, 1953. Val Rutter recalls, 'This shows my class, the second infant class, during Coronation year and you can see a picture of the Queen on the back wall. I'm second from the left on the front row and my cousin Irene Hall is also on the front. Other children include Jean Price, John England, Janet Dickens, George Biggs, Robert Evans, Janet Leighton, Pauline Aston and Lauren Goodhall.' (*Val Rutter, née Ling*)

St Barnabas's School, 1946. This was taken in the junior boys' playground which backed on to Sherborne Street. Mr Newman, the headmaster, is on the back row on the far left. Among the group are, back row: Dennis Aston, Alan Meddings; third row: Irene Ford, Joyce Lewis, Mavis Chare; second row: Ann Price, Ann Piper; front row, on the floor: John Hipwood, Jimmy Foxall, Brian Stephens. (*Mavis Ridley, née Chare*)

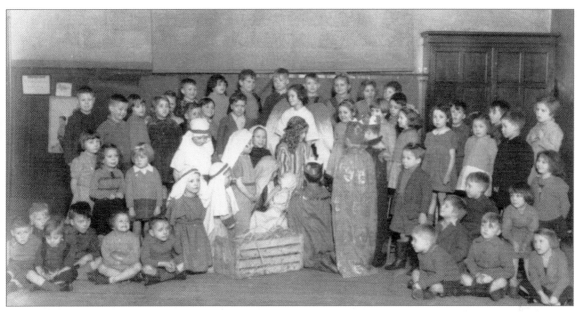

Nativity play at St Barnabas's School on Ryland Street. Stuart Hughes, born in 1941, is in this photograph, and looks about five years of age, which dates the photograph to about 1946. (*Stuart Hughes*)

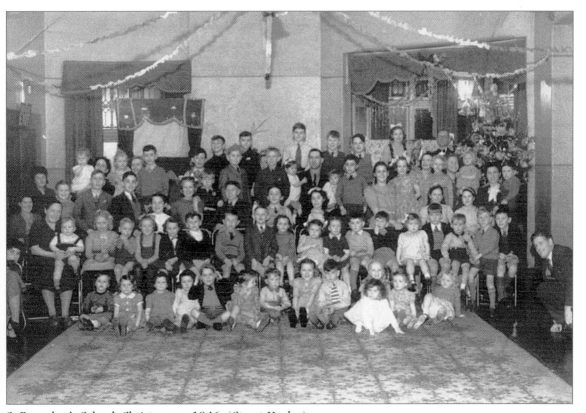

St Barnabas's School, Christmas, *c.* 1946. (*Stuart Hughes*)

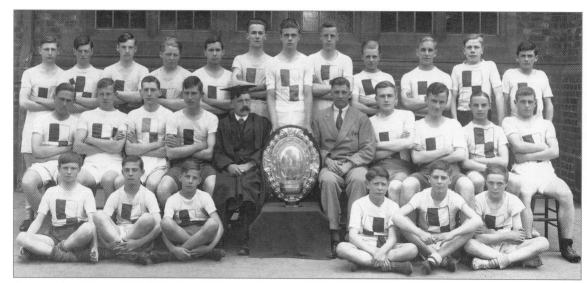

George Dixon Secondary School, runners, 1929. The team became joint winners of the secondary school championships and are seen with the winners shield and senior relay cup. Back row, left to right: Chapman, Cox, Jinman, Cutler, Prosser, Stephens, Warren (captain with hands on trophy), Sands, Newman, Knight, Jones, Carling. Middle row: Else, Coles, Marks, Merriman, Mr. Brown (headmaster), Mr. Garden (sportsmaster), Howell, Harrison, Hawkins, Garbett. Front row: Peak, Hobbs, Shaw, Tarplet, Jones, Hall. (*George Dixon International School*)

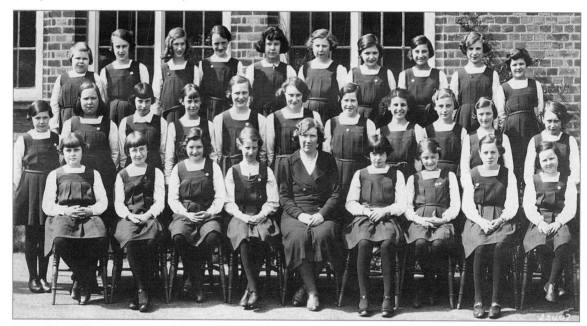

Form IIP at George Dixon Girls' School, 1935. Back row, left to right: Pauline Rowley, Marjorie Barratt, Eileen Betts, Joan Andrews, Joan Hampson, Audrey Weston, Audrey Brown, Audrey Woods, Margaret Williams, Violet French. Middle row: Marie Evans, Mary Pegg, Doreen Norton, Margaret Gibbs, Joan Carter, Gwen Smith, Joan Lewis, Joy Cotton, Barbara Fisher, Edith Fellowes, Doris Bird. Front row: Joy Neale, Doris Smith, Muriel Grove, Beryl Swinfen, Miss Shuker, Betty Hardwick, Betty Wright, Jean Archer, Ruth Hopkins. (*George Dixon International School*)

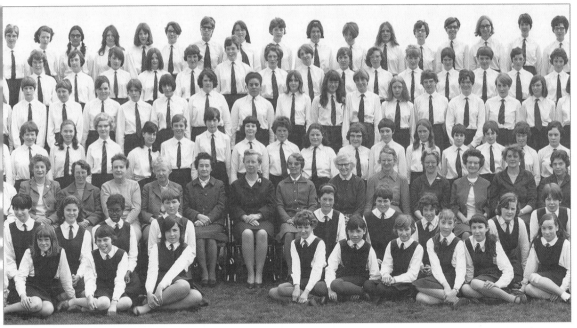

A section of the panorama photograph produced for the girls of George Dixon School in April 1967. (*George Dixon International School*)

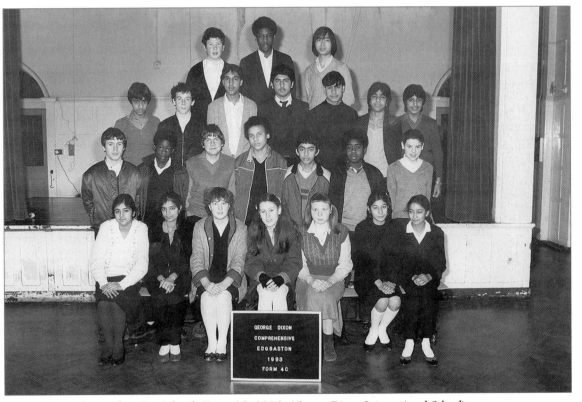

George Dixon Comprehensive School, Form 4C, 1983. (*George Dixon International School*)

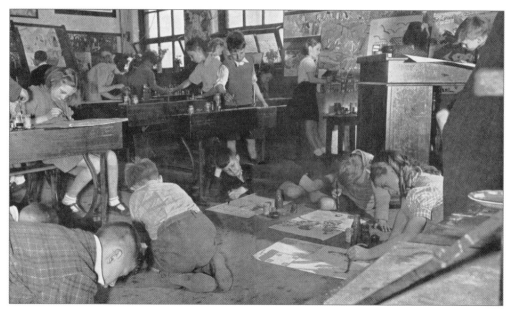

Steward Street School, 1943. The Ministry of Education produced a booklet to illustrate 'The Headmaster's Experiences with Children Aged Seven to Eleven' during the difficult war years and these two photographs appeared in it. Basically the school developed a curriculum that was based more on art and creative expression than the traditional three Rs. The photographs were accompanied by text that stated: 'Interest, concentration, imagination and movement. All the arts have a common beginning in movement.' The headmaster believed, 'If I could get that confidence, that interest, that concentration from each child which arrives from creative art, I had the ground well prepared then for the three Rs.' In the foreword to the book Headmaster Mr A.L. Stone describes what he has achieved in an environment 'which others may have found discouraging' and he shows 'how much can be done with courage, sympathy and imagination'. He adds, 'In arranging for the publication of this pamphlet the Minister hopes that it will encourage other teachers to experiment on this and other lines.' Pupils include Harry Dugmore, Audrey Allport, Margaret Dark and Rose Saunders. Ivor ?, John Edwards and June Lyndon. (*June Gurley, née Lyndon*)

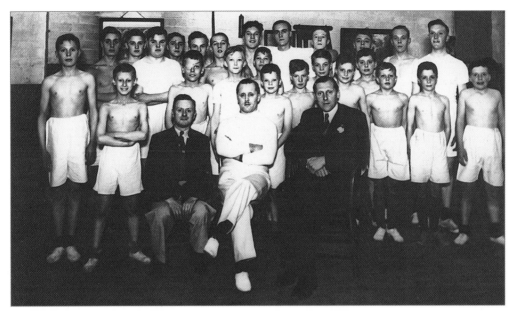

The gymnastics club, St Mark's Street School, 1938. Bert Martin, the instructor, is in the middle of the front row, flanked by Harry Swain, the caretaker, and Geoffrey Lloyd MP. The gymnasts include Bert Vale, George Checkley, Arthur Checkley, Leslie Checkley, Harry Milward, Harold Rudge, Bill Cowley, Norman Peters and Bill Gannon. Leslie recalls, 'I was twelve at the time and really enjoyed the gym club. We met every week and gave annual shows.' (*Leslie Checkley*)

St John's School, 28 July 1967. St Mary's Street runs off to the right and Johnstone Street to the left, where it joins the shops on Monument Road. One of the shops, boarded up ready for demolition, is a branch of Hickman's greengrocers.

Pupils celebrate completing a huge painting at St John's School, *c.* 1948. Johnny Landon (of the bathroom empire) is on the immediate left and June Grandy is on the far right. One of the other pupils is John Thomas and one of the girls may be Pauline Thomas. (*Johnny Landon*)

The new school built to replace St John's opened as Ladywood County Primary School in April 1961. It was later renamed the more familiar St John's School. Unlike the original school this one was built with extensive playgrounds and green open spaces. The planners' dream estate of maisonettes and flats surrounds the school. Friston Street once ran across the bottom of the picture. (*Spring Hill Library collection*)

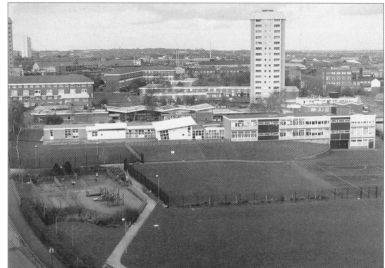

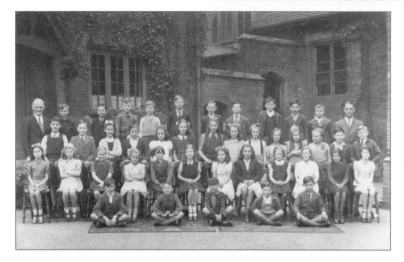

St George's School, 1947. The children include Ron Woolley, David Best, Ron Brooks, Beryl Bryan, Derek Buffery, Harold Brown, Carl Sutton, Keith Herbert and Pat Cleaver. The teacher on the right of the back row is Mr Harper; on the left is headmaster William Pillinger, who sadly passed away early in 2004 at the age of ninety-eight. (*Harold Brown*)

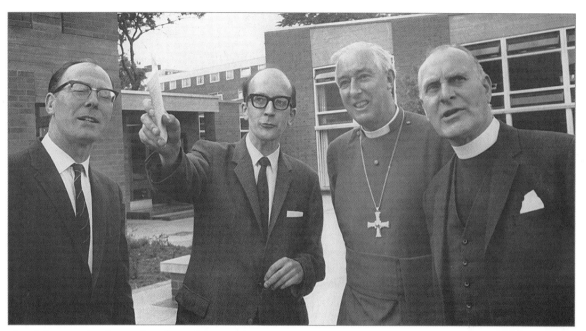

The dedication by the Lord Bishop of Birmingham and the formal opening by Dr R. Temple, a former pupil, of the new St George's Church of England Junior and Infants' School, held on 14 June 1968. The first school opened on the site in 1854 when 'children used to come to school along Monument Lane which was a quiet and muddy lane where now busy Monument Road runs'. In 1952 the school was granted 'aided status' which is an arrangement by which the state pays a large proportion of building and maintenance costs and the church pays the rest to ensure that the school is retained as a church school. The managers of the school had to find 25 per cent of the cost of the new school. Chairman of the managers at the time was the Revd G.H. Browning OBE, Vicar of St George's. Mr Ernest Just was the headmaster. (*St George's Primary School Archive*)

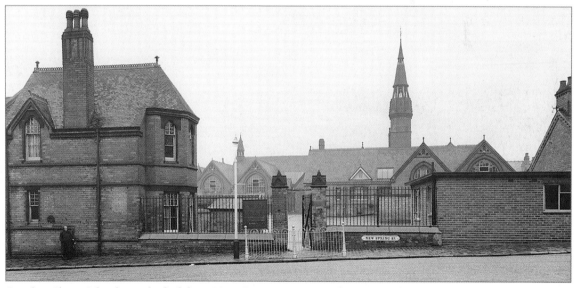

Camden Street School as it looked from New Spring Street, October 1961. Camden Street Board School, as it was originally called, opened in 1890. A secondary girls' department became a separate school in 1945, known as Camden Street Girls' County Modern School. (*Johnny Landon*)

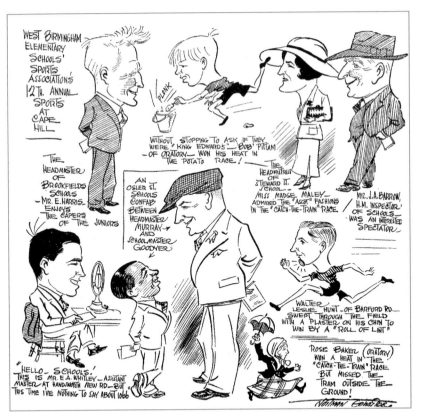

The events of the West Birmingham Elementary Schools' Sports Association Annual Sports, held at Cape Hall in 1935, as portrayed by a newspaper cartoonist.

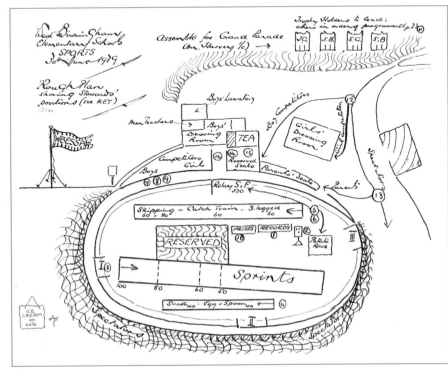

The layout of the sports arena at Cape Hill for the June 1939 sports day.

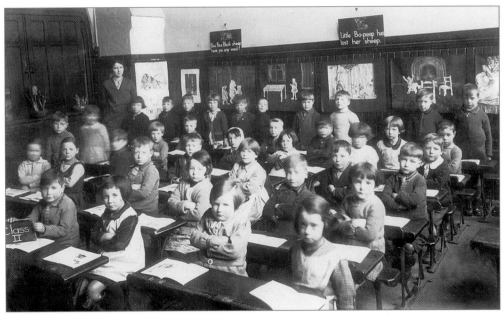

Steward Street School, early 1930s, when 'Little Bo Peep' and 'Baa Baa Black Sheep' were compulsory. (*Jack Ridgway*)

BIRMINGHAM SCHOOL BOARD.

SCALE OF SALARIES FOR ASSISTANT TEACHERS.

REVISED UP TO DECEMBER, 1889.

Unless otherwise determined by special resolution, the following will be the scale of salaries for legally qualified Assistant Teachers:—

First Assistant Masters in Boys' Schools.

Not less than £80, nor more than £120 per annum.

The maximum salary of £120 per annum not to be paid until after five years of service as First Assistants. The maximum not to exceed £100 until after five years' service.

First Assistant Masters in large Classroom Schools.

Not less than £80, nor more than £130 per annum.

The maximum salary of £130 per annum not to be paid until after five years of service as First Assistants. The maximum not to exceed £110 until after five years service.

Junior Assistant Masters.

Not less than £55, nor more than £70 per annum.

First Assistant Mistresses in Girls' Schools.

Not less than £65, nor more than £100 per annum.

The maximum salary of £100 per annum not to be paid until after five years of service as First Assistants. The maximum not to exceed £80 until after five years' service.

First Assistant Mistresses for Girls' Departments in Classroom Schools.

Not less than £65, nor more than £120 per annum.

The maximum salary of £120 per annum not to be paid until after five years of service as First Assistants. The maximum not to exceed £100 until after five years' service.

First Assistant Mistresses in Infants' Schools.

Not less than £65, nor more than £80 per annum.

Junior Assistant Mistresses in Boys' Schools.

Not less than £40, nor more than £55 per annum.

Junior Assistant Mistresses in Girls' and Infants' Schools.

Not less than £40, nor more than £50 per annum.

All salaries of Assistant Masters and Mistresses will remain fixed at the amount first agreed upon, until raised by resolution of the Board.

A few additional Assistants may be appointed from time to time, on special recommendation, who, though not *legally* qualified, give evidence of good education, and desire to obtain certificates. In particular cases the rate of salary will be specially determined on by resolution of the School Management Committee.

The scale of teachers' pay in Birmingham in 1889.

Icknield Street School. (*Spring Hill Library Collection*)

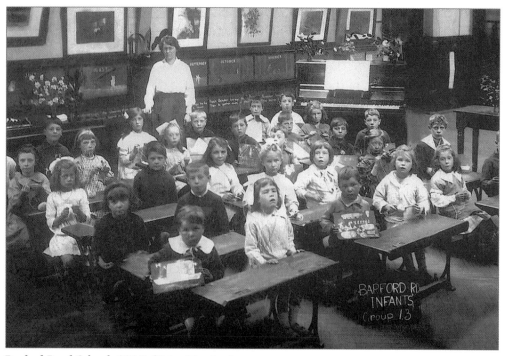

Barford Road School, 1917. (*Peter Marriner*)

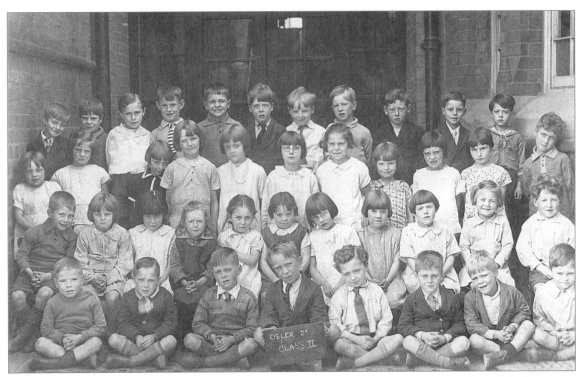

Osler Street School, class 2, c. 1930. The back row includes Tranter, Peters, Powick, Ridley, Sideboth, Reeves, Shutts, Harris, Williams and Daniels. Two of the girls are Connie Barrett and Joanne Earp. (*Alf Tranter*)

The *Osmag* was the magazine of Osler Street Senior Boys' School. This is the front cover of the December 1932 issue. Articles included a message from the headmaster who wrote of the change that took place in the school that term owing to reorganisation of the school, which necessitated a separate junior and infant school and enlarged secondary school to take in senior boys from St George's and St Barnabas's. The head stated: 'What vague wonderings we all had as to how the new conditions would affect the school and if we should be the same happy community. What of the new staff and boys? They would be wondering too! Now at the end of the first term I want to congratulate both staff and boys on the way they have settled down. They have proved both in work and play that they are real sportsmen and we are proud to have them amongst us.' *Osmag* also featured a goodbye to Mr Lindsay 'after a long period of faithful service'; a report on the annual school trip to Aberystwyth: 'it would be difficult to conceive a more perfect outing – 230 miles in an open coach with 15 hours of sunshine'; and boys were reminded of the bulb-growing competition: 'each class has been supplied with nine bulbs'. Clearly everyone had a blooming good time at Osler Street. (*Len Thornton*)

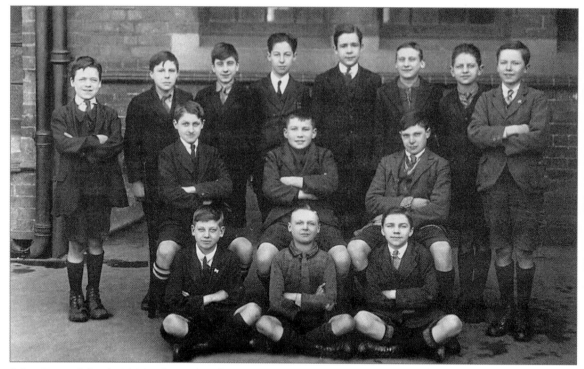

Osler Street School, 1926. This was taken on their leaving day. George Gupwell is fourth left, back row. (*John Gupwell*)

Osmag, the magazine of Osler Street School, June 1952. The magazine thanked Belliss & Morcom, Canning & Wildblood, Ladbrooke Stampings Ltd, Lesbrook & Co., McKechnie Bros Ltd, Henry Wiggins & Co., Williams & Sons and Yarwood Ingram & Co. for their contributions to the last Christmas party: it must have been some party! *Osmag* also reported on the success of the school in many sporting competitions. There was a report on a chess contest when the New Zealand chess master visited and played eighteen boys simultaneously, and one boy, Tom Farley, 'brought honour to the school by winning the Individual Chess Championship of the Birmingham Secondary Modern Schools', the Intermediate football team lost the championship to Barford Road only on goal average', and the swimming team did exceptionally well at the Annual Gala taking the championship comfortably and with it the new McKecknie Shield which now graces our school hall'. Meanwhile the Mitchell's & Butler's Sports Ground was being prepared ready for athletic practices and the cricket team was preparing for action against Handsworth New Road in the Docker Shield. (*John Richmond*)

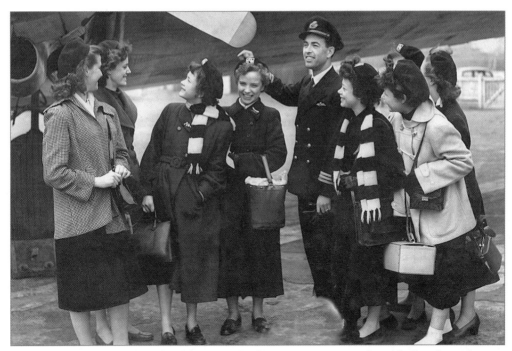

Leavers from Osler Street Girls' School, at Elmdon Airport, 1954. The girls flew from there to London for a visit to Westminster. Irene Staines is in the middle by the pilot, Maureen Richards is second left and Shirley Goode is on the extreme left of the photograph. (*Shirley Cleary, née Goode*)

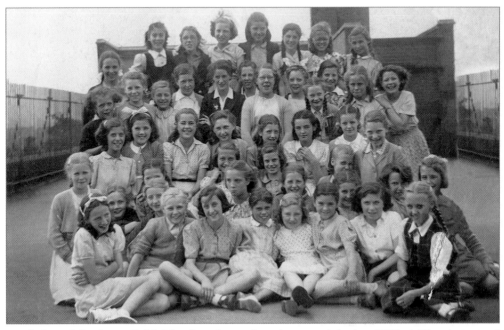

Pupils from Osler Street Girls' School on the rooftop playground during 1953–4. The playground was created to make more space for recreation and play time, given that the school was surrounded by densely packed houses and space was at a premium. (*Irene Staines, née Lowe*)

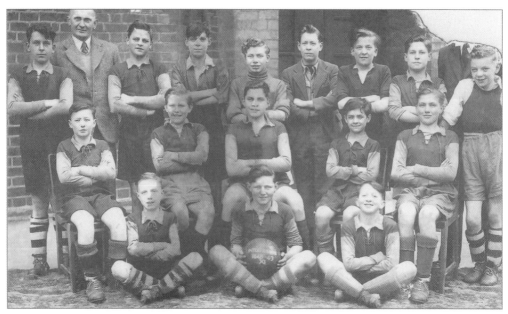

Osler Street School Senior Boys' football team, 1948/49. Back row, left to right: -?-, Mr Marshall (headmaster), David Best, Peter Berrington, -?-, Ron Phillips, Walter Knight, -?-, Alan Hicks. Middle row: Johnny Hart, Ron Harris, Roy Gurley, Terry Lilley, Don Link. Front row: Trevor Rachael, Cliff Hawkins, Derek Buffrey. (*Roy Gurley*)

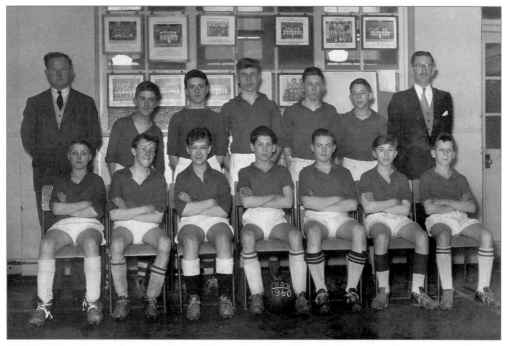

Follett Osler Secondary Modern School for Boys' football team, Champions of West Birmingham, 1959/60. Back row, left to right: Mr Upton, D. Winfield, P. Murray, J. Hardy, J. Bradley, R. Smith, Mr Hughes. Front row: N. Howell, M. Cooper, J. Harden, T. Cowie, -?-, -?-, J. Lawler. (*Pete Murray*)

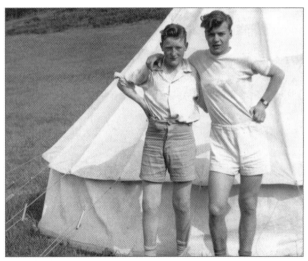

Ray Hardy and John Thomas, aged fifteen, at Osler Street Boys' School summer camp, 1956. Douglas Busk recalls: 'I was fortunate to go on the first school camping trip in 1951 to Skerries, north of Dublin. The cost was £7 per head. Following that, every year camp was set up between Aberdovey and Towyn in Mid-Wales. The teachers who accompanied us were Cecil Jones and Harry Rowland. Mr Jones was a keen fisherman and did well with a shotgun. He would take off at the crack of dawn and return with rabbits for our evening meal, yes, rabbit stew! We lived very well on trout too. I always looked forward to the camps and even returned to help out after I had left school.' (*Douglas Busk*)

Rita Smith, Osler Street Senior Girls' School, 1947. The Christmas-style card format was typical of the postwar years. (*Rita Trentham, née Smith*)

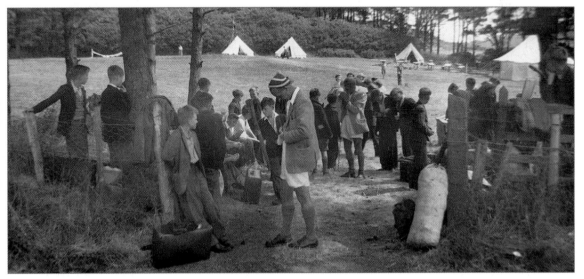

Osler Street Boys' School, 1953 or 1954. Mr Jones, centre, gathers the boys together at the end of the summer camp. (*Douglas Busk*)

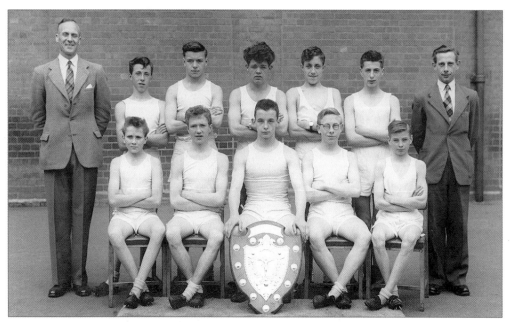

West Birmingham Athletic Champions show off their trophy at Osler Street School, *c.* 1954.
Back row, left to right: Mr Sutcliffe, J. Gill, J. Thomas, C. Lucas, -?-, A Hill, Mr Lewis.
Front row: -?-, -?-, D. Freeman, D. Busk, -?-. (*Douglas Busk*)

Before the closure of Osler Street School two former pupils, David Freeman, left, and Douglas
Busk, right, returned to the school and met up again with former art teacher Mr Jones, centre.
(*Douglas Busk*)

Osler Street School as it looked shortly before demolition. (*Malcolm Davies*)

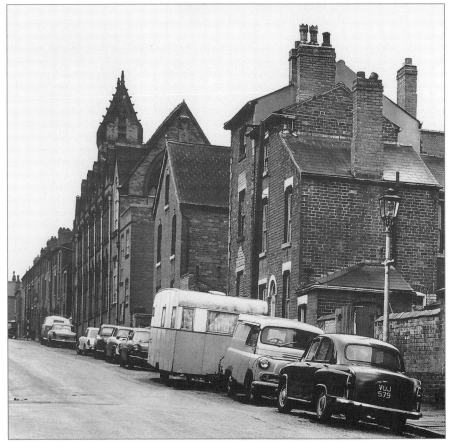

Osler Street School from Clark Street, 18 March 1968. Demolition of the building began on 5 January 1981 and was completed on 10 February.

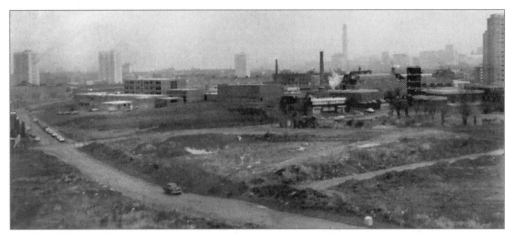

The view from the art room at the Osler Street School building, *c.* 1974. By that time Osler Street School had become Ladywood Secondary School and the former Osler Street building was being used as an annexe. Ladywood School, opened in 1972, is in the centre of the photograph. The dominant street is Clark Street leading down to the junction with Icknield Port Road. Bill Landon & Sons' premises can just be seen on the immediate left. The remains of Hyde Road lead off Clark Street to the left. Teacher Malcolm Knight recalls, 'Huge lorries used to come and collect piles of earth from the derelict land and it was used to fill in the railway line near to Summerfield Park. Dust was always a constant menace! During digging they found a 1890s plate from Blackpool and bits of bottles, pottery and toys that we put in a display case in the school.' (*Malcolm Knight*)

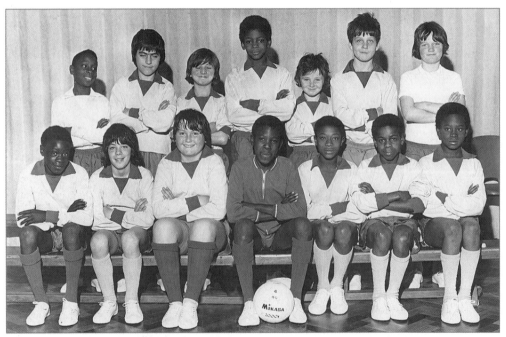

Ladywood School football team, mid-1970s. Back row, left to right: Kevin Whitehouse, Mickey Burns, Tony Mooney, Denis Gregory, Tony Bryant, Chris Gauril, Tony Clark. Front row: Lionel Tweed, David Brown, Patrick Gordon, Lloyd Clark, Mark Hancock, Ricky Codling, Peter Harrison. (*Billy Codling*)

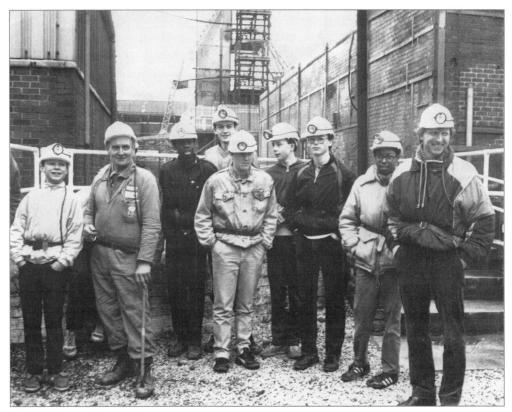

A combined geography and history field trip from Ladywood School, *c.* 1984. The 'educational visit, not trip' was to the Chatterley Whitfield Mining Museum near Stoke-on-Trent. Pupils include Chris Douglas, Darren Hawthorn, Chris Heard, Junior Carby and Michael Messam. The teacher on the right is Paul Nagle.

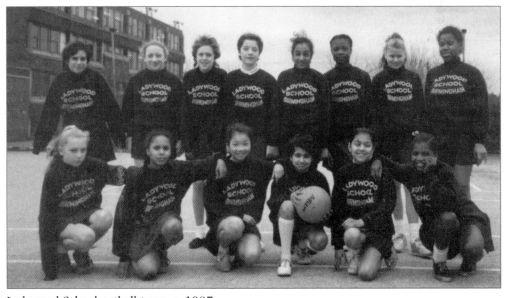

Ladywood School netball team, *c.* 1987.

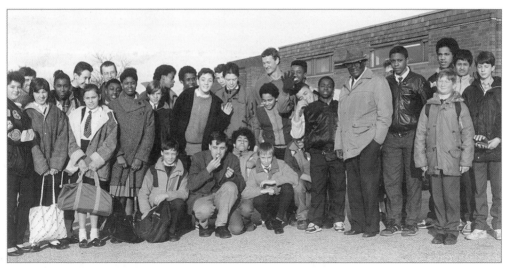

Popular local jazz man Andy Hamilton, sixth from left, visits Ladywood School, where his children had been educated, in February 1988. Andy is with members of the Steve Berry trio, teacher Alan Cross and many of the pupils. The pupils include Stuart Bevan, Angela Bryan, Brett McGowan, Dean Dodd, Andrew Morris, Jaswant Najran, Malcolm Soloman, Jon Morton, David Hughes and Spencer Cash.

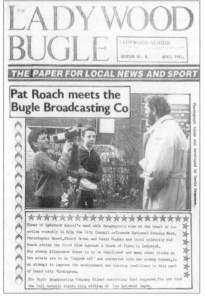

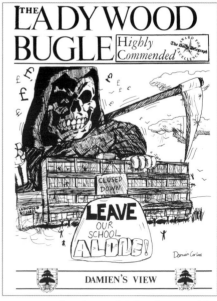

Two of the thirty covers of the *Ladywood Bugle*, the newspaper of Ladywood School, started by teachers Bev Fiddes and Norman Bartlam in May 1986. The newspaper followed in the traditions set by *Osmag* (see pages 83 and 84). The left cover from April 1987 features local personality Pat Roach being interviewed at a ceremony to mark the redevelopment of maisonettes in Ledsam Street (see *Ladywood in Old Photographs*, Sutton Publishing, page 144). The cover on the right is from October 1989 and features a superb cartoon, drawn by pupil Damien Carless. It shows the grim reaper hovering over the school during the campaign to save it from closure. The school did eventually close but not until the newspaper had won the prestigious *Daily Telegraph* School Newspaper of the Year Award!

Pupils from Ladywood School take part in a 'Clean-up Ladywood' campaign in St Vincent Street West, *c.* 1988. The project was filmed for the school's video news programme and was featured on BBC Radio WM. Here interviewer Brendan Brogan gives the BBC Radio WM afternoon presenter Gyn Freeman a taste of her own medicine, watched by cameraman Mark Bartlett and Daniel Millward.

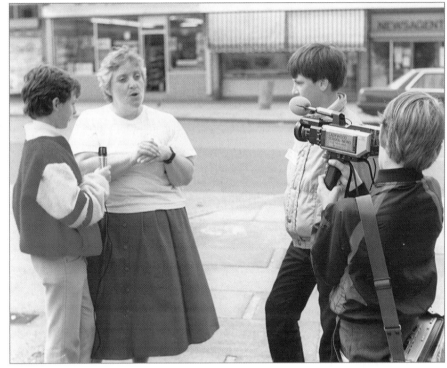

Ladywood School: teacher Norman Bartlam's form outside the Hall of Memory returning to school after an educational visit, *c.* 1984.

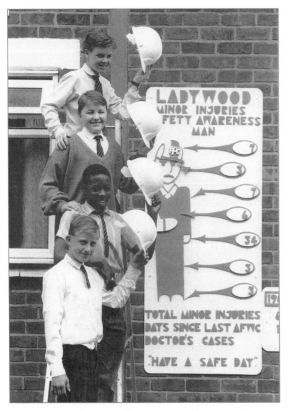

Pupils from Ladywood School help to make the future a little safer for workers at PPG International, formerly Docker Bros. Paints in Rotton Park Street. Pupils built a 6ft-high perspex man to remind staff about the number of accidents that have happened at the works and to encourage them to think more about the hazards of working in a paint factory. The project was part of a design and technology assignment set up by teacher Denziel Watts. The finished work was displayed on a prominent wall at the factory and regularly updated until the factory closed in 2003. Pictured are Robbie McMorine, Adrian Clarke and Colin Douglas, all aged fourteen, and David Payne, thirteen.

Ladywood School teacher Fred Cork with pupils on a visit to Drayton Manor Park, July 1989.

Ladywood School PE teacher Alan Cross hands over a trophy to Junior Carby, the school's Outstanding Sportsman of the Year, c. 1988.

4

Events & Happenings

Celebrating the Coronation in Beach Street, 1953.
(*Dorothy Smith, née Haywood*)

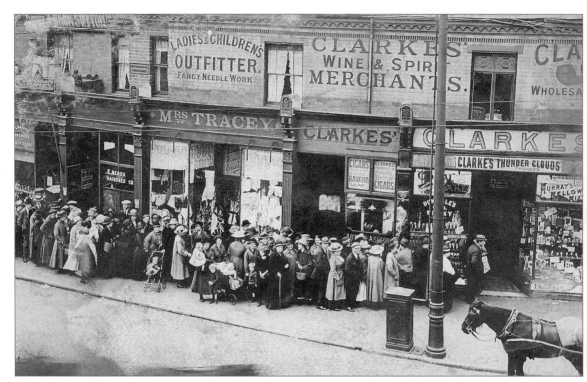

Queuing for whisky in Northbrook Street towards the end of the First World War. (*Jill Kershaw*)

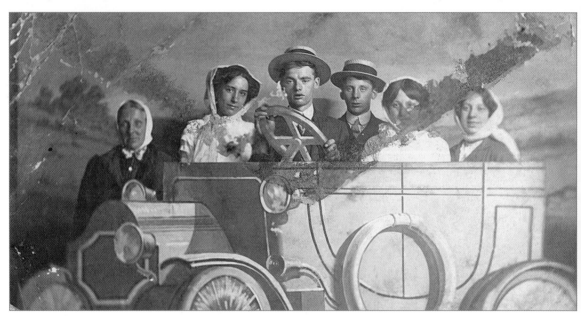

A family snap taken after a First World War wedding held at St John's Church: the car had not been taken in for a service! This was probably taken at a local photographer's studio after the wedding ceremony. Len Thornton says, 'The two men are my dad, left, and his brother. This was presumably taken at a photographer's rather than in the church. They all lived in Friston Street and probably only one person in the entire street owned a real car in those days.' (*Len Thornton*)

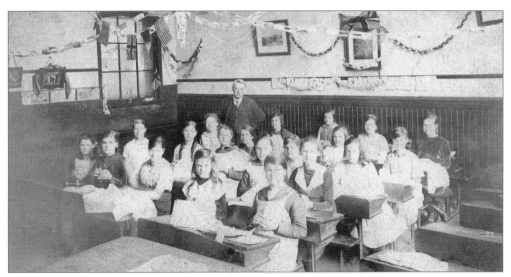

Camden Street School, 1918/19. Andy Terry says, 'The decoration implies this was taken during the Armistice Day celebrations. My grandmother Selena Taylor is far left on the front row. The headmaster was Mr Trought.' (*Andy Terry*)

November 11th 1918.

The Revd. Manager has said that the children are to be sent home at 11.30 & to stay there until Wednesday morning as the result of Peace – the cessation of hostilities.

nov: 15th

The attendance this week has been exceedingly bad. 64% only. Some of the children have Influenza – but the majority are taking a holiday.

Miss Alice Barley, who is fully qualified for ambulance work, was called out of school on Monday at 11.45 to go to Snow Hill Station to attend the wounded soldiers who were passing through. She returned to school about 3 p.m.

Extracts from St Peter's RC School logbook. One records the cessation of hostilities in 1918.

Pupils from Osler Street School evacuated to Marden in Herefordshire, *c.* 1940. (*R. Horton*)

Oranges! how sadly we think of the fruiterers' shops of pre-war days with the crates of oranges piled up and the window arranged and decorated gaily with them. Now we do not get any oranges and we have only memories to fall back on.

I am sure we all look forward to the days after the war when we shall be able to have plenty of oranges again.

Barbara Copper, a pupil at Osler Street School, wrote an essay in 1943 about one of the wartime hardships . . . the lack of oranges! This is an extract from the essay taken from her exercise book. Today teachers in local schools use her essays to give pupils an insight into life in the Second World War. Have you any similar work? (*Geoffrey Inshaw*)

Steward Street School, 1943. The school was the subject of a wartime experiment in which calming subjects such as art and drama were given precedence over the more traditional 3Rs (see page 76). Notice the air raid shelters in the playground. King Edward's Road goes up the hill. (*June Gurley, née Lyndon*)

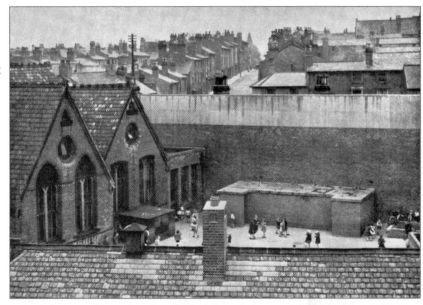

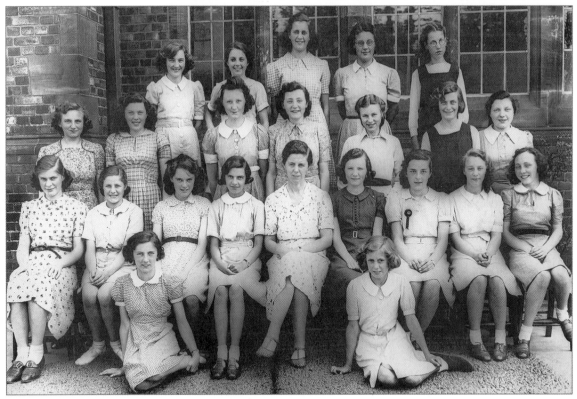

Class IVC at George Dixon School, summer term 1941. Back row, left to right: Joan Walker, Dorothy Coward, Beryl Young, Betty Webster, and Joan Bunn. Middle row: Doreen Simpson, Paula Barrowcliffe, Joan Cross, Betty Prime, Gillian Key, Margaret Cope, Mary Couzens. Front row: Margaret Giles, Joyce Halford, Kathleen Gardner, Betty Crabtree, Miss Gosling, Doreen Pritchard, Edna Hinton, Valerie Hackett, Gwyneth Davies. Kneeling in front: Audrey Staniforth and Barbara Coyne.

An unidentified man outside St Mark's Street School, 1940. Notice the traditional ornate iron railings that stopped children running out of school straight into the road. St Mark's Street School closed in 1940, possibly owing to falling numbers as a result of evacuation. A note in the logbook of Nelson Street School reads, '21 August 1940. Informed that St Mark's School would close on 1 September and that a good number of children would be transferred here.' (*Alan Wyant*)

Bill Spencer prepares for Home Guard duty.
(*John Spencer*)

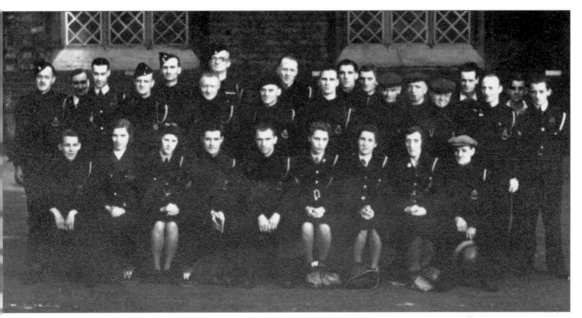

The ARP team gather for a photograph outside their headquarters at St Mark's Street Church. (*Alan Wyant*)

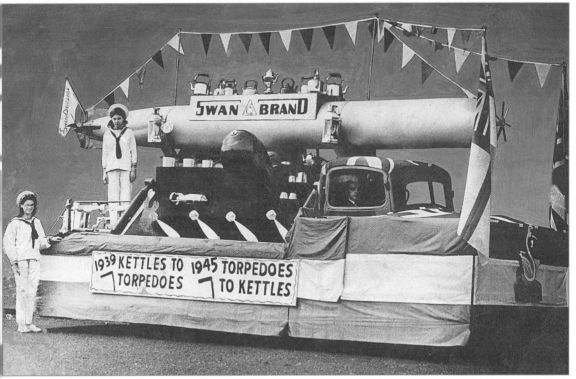

Kettles to torpedoes! A publicity photograph taken for Bulpitt & Sons at Spring Hill. It clearly shows they did their bit for the war effort. Pots and pans were melted down and the manufacture of such items virtually suspended for the duration of the war. The metal was used to manufacture essential items, mainly in this case torpedoes.

Ted Grice, a fireman at Docker Bros paint factory on Rotton Park Street, which was a major supplier of camouflage paint for the war effort. On the night of 28 July 1942 a severe bombing raid led to the loss of four firemen from the neighbouring firm of Wiggins when a wall collapsed on them while they were fighting a blaze. Two nights later in a follow-up raid another man died when an incendiary bomb fell nearby. A plaque was later erected in the rebuilt factory. It bears the inscription, 'This tablet is inscribed and respectfully dedicated in proud tribute and in graceful remembrance of fire-fighters who lost their lives following enemy action a few paces from this spot.' (*Josie Coughlan, née Grice*)

Below: Firefighters in Rotton Park Street, July 1942. The factory was partially destroyed but production was up and running within weeks. The damaged mill was completely rebuilt after the war. Docker's was eventually taken over by other companies and in spring 2003 the latest owners, PPG, did something even the wartime bombers couldn't do – they ceased production at the site. The manufacturing side of the business was transferred overseas leaving only a sales office at a new location on Hagley Road. The historic Rotton Park Street site awaits redevelopment. (*PPG Archives*)

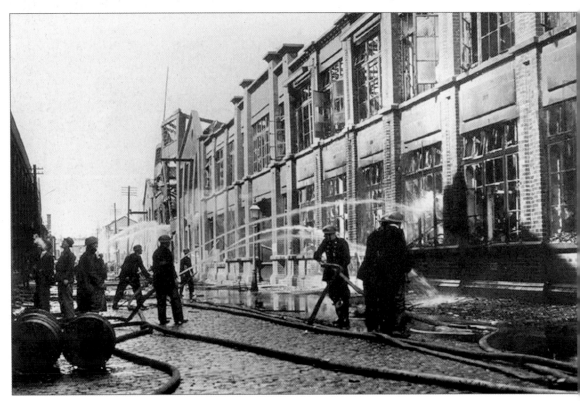

The Duchess of Kent
visits the team from
TS *Vernon* at a special
event held at the
Botanical Gardens in
September 1945.
(*TS Vernon Archive*)

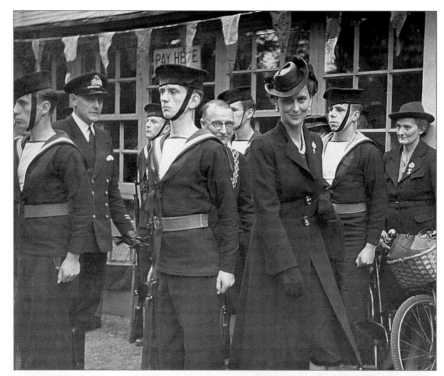

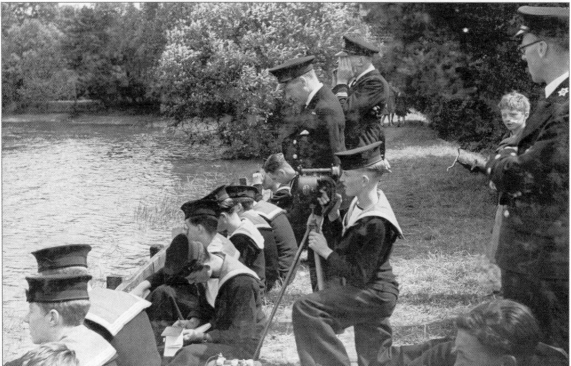

Practice work with an Aldus lamp for the team from TS *Vernon*, *c*. 1943. This was taken at either Edgbaston Reservoir or Earlswood lakes where they did a lot of training. (*TS Vernon Archive*)

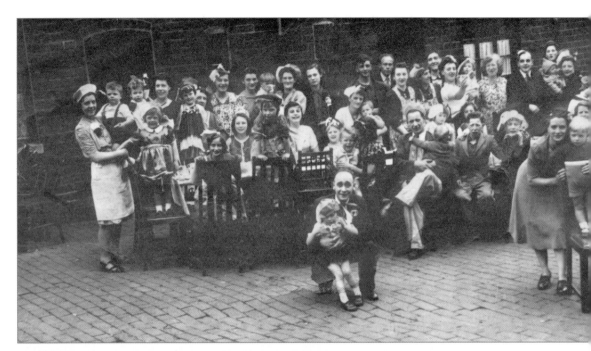

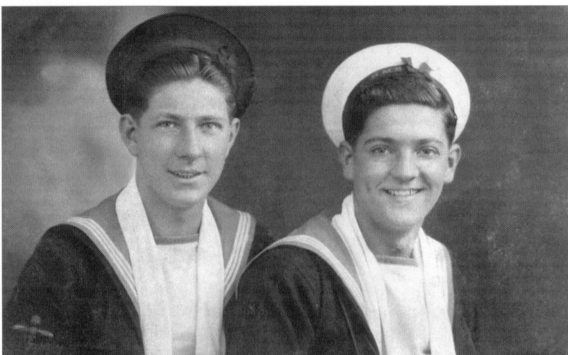

Harry Usher, left, and his brother Ray were two Ladywood lads who served in the Navy. They are pictured here when home on leave in 1944. Harry served on HMS *Indefatigable* and was on board when the ship became the first British ship to be hit by a kamikaze plane. 'The deck of the ship was made of metal and the plane bounced off,' he says. Ray was less lucky; he was on board HMS *Pylades* off the Normandy coast when it was torpedoed, and he had to be rescued from the sea. (*Ray Usher*)

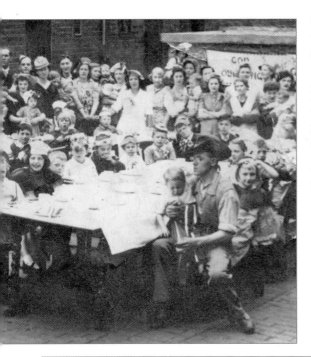

The end of the Second World War is celebrated in the yard known as the shipyard on Ledsam Street. George Bailey recalls, 'This was situated at 28, back of 181 Ledsam Street, next to Archdale's factory. It consisted of thirty-six houses and about a hundred children; most of them were at this celebration. My mother and younger brother are on the back row. I was fourteen at the time and remember the great joy and relief that we all expressed when we knew the war was finally over. Notice there are very few young blokes on the photograph as they were still away with the forces.' (*George Bailey*)

> children spent a thrilling hour in the playground while they watched Alec Henshaw work wonders with a 'Spitfire'. It certainly was a marvellous display.
>
> Earlier in the day, a captured Messerschmitt was placed outside the Hall of Memory. Needless to say, most of these children, had visited the exhibit during the afternoon.

> ... The children returned to school last Monday after the holiday. On the nights of the 9th–10th, there were again very severe air raids on Birmingham — the bombs fell very near to the school — some at the Prince of Wales

Two interesting extracts from the log book of St Peter's RC School, 1940.

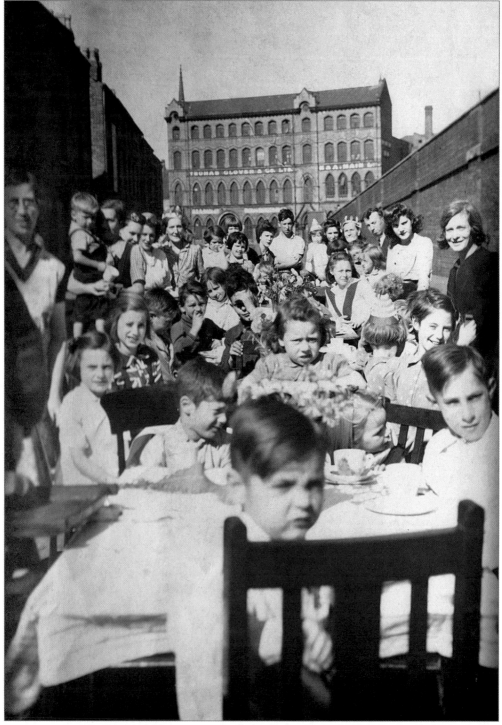

The gothic-style industrial premises of Thomas Glover dominate the end of Sheepcote Lane, but the locals aren't concerned with it as they pose for this photograph during their VE-Day celebration. (*Irene Daisy Smith, née Carter*)

Two unnamed children at the VE-Day celebrations, which were held at City Road School. It was some time before everything was 'off ration', but at least this child was forward thinking! (*Spring Hill Library Collection*)

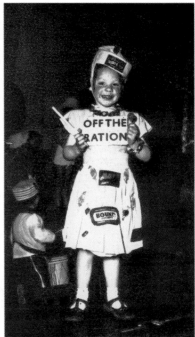

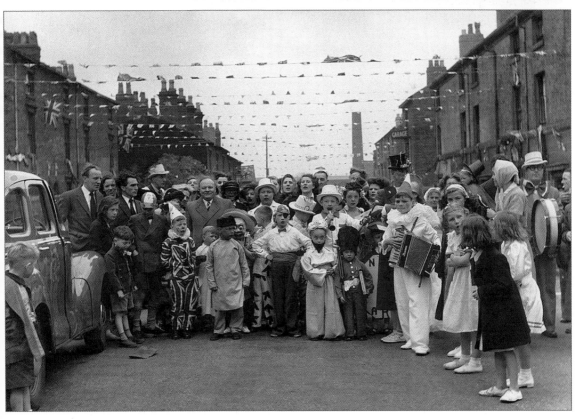

VE-Day celebrations in Icknield Square. (*Alan Wyant*)

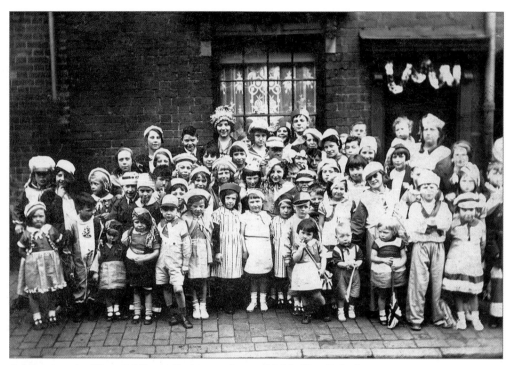

Celebrating the Silver Jubilee in Essington Street, 1935. (*Sue Teckoe*)

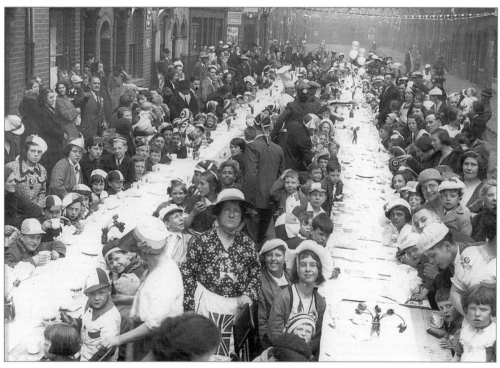

King George VI Coronation celebrations held in Shakespeare Road, May 1937. (*Birmingham Central Library collection*)

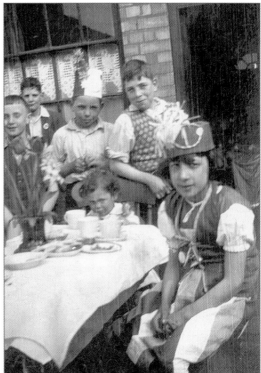

Two scenes from the 1935 Jubilee celebrations in Nelson Street. *Above:* Three people facing the camera on the left are Doll Sedgley, Ralph and William Evans. *Above, right:* Two of the children are Ronnie and Billy Evans. The girl at the front is Edie Rastall. At school the children were presented with a mug and a tin of chocolates. (*Jo Randle*)

The 1935 Jubilee celebrations naturally involved a visit to the local pub. Here bunting is hanging outside the Steam Clock on Morville Street. Henry Hall, on the left, poses with neighbours Messrs Stokes, Kemp and Cotterill, and the short-sleeved landlord. (*Phil Trentham*)

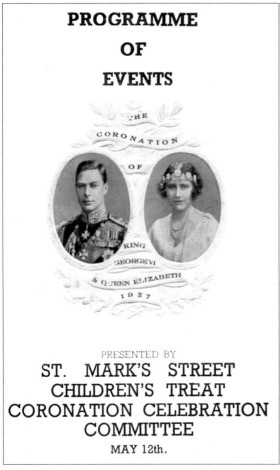

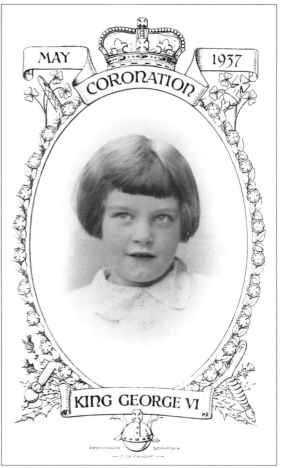

The programme of events for the children's treat in St Mark's Street to mark the Coronation of King George VI and Queen Elizabeth in May 1937. Events got underway at 10.00 a.m. with community singing by all. At 10.15 a.m. there was a fancy-dress parade for children up to the age of two. This was followed by a parade by older children. Sporting events were held between 11.00 and 2.30 p.m. Then there was a Children's Parade for tea, with a march to the schoolroom. Events continued until midnight. Once back at school children had commemorative portrait photographs taken before settling back into lessons. This one shows seven-year-old Barbara Cooper. She was a pupil at Osler Street Infants at the time, although she later went to St George's School and Osler Secondary. (*George Steel and Geoffrey Inshaw*)

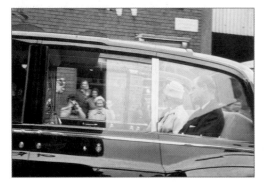

The Queen and Prince Philip travel along Browning Street in the mid-1950s on a visit to the Queen Elizabeth Hospital. (*Jim Taylor*)

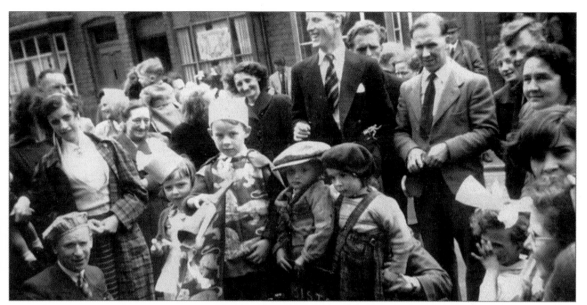

Residents of Daisy Road enjoy the Coronation festivities in 1953. The two children on the left are Carol Allen and John Gupwell. The two next to them are dressed as the Bisto Kids and are clearly intent on making a meal of things! (*John Gupwell*)

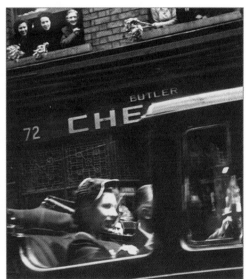

A royal visit to Birmingham in which the royal car drove along Ledsam Street, June 1951. Princess Elizabeth seems to be accompanied by her husband, the Duke of Edinburgh, as they head towards Victoria Square for the unveiling of the Queen Victoria statue. The people in the windows are in the Gould family's flat at 72 Ledsam Street, which was above Butler's chemist shop. (*Johnny Landon*)

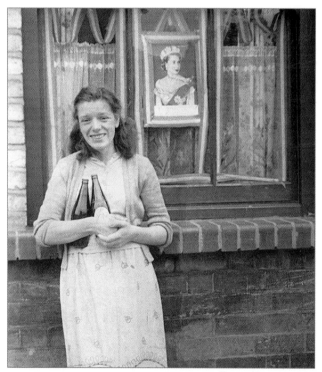

Adults prepare to join in the Coronation Day fun, 1953. Kathleen Quinlan, the author's aunt, gets in a bottle or two as the Queen-to-be nods her approval from a window in St Mark's Street. (*Jimmy Quinlan*)

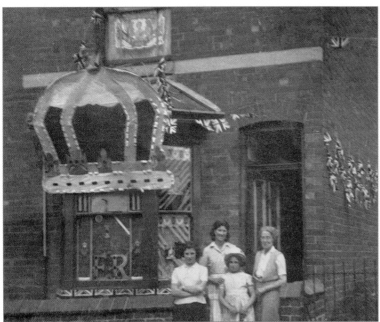

Every one's a gem or at least a crown. Shirley Hickin recalls, 'This is our house at 35 Bellefield Road. The crown decoration was handmade using bicycle reflectors as rubies and the crown was tied to the bedpost by a rope through the bedroom window. It was another unforgettable day. The whole street dressed up and there was a huge street party.' Pictured are Lily, Shirley, Dawn, Nan and Dorothy Welch. (*Shirley Hickin*)

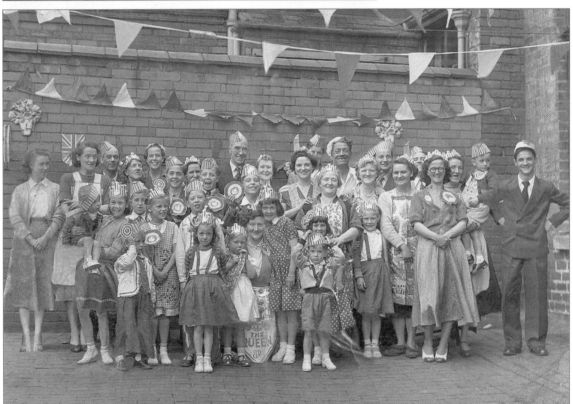

Children and grown-ups enjoy fun and games in the playground at Dudley Road School to celebrate the Coronation, 1953. Are the 'big children', the grown-ups, enjoying the event more than the children? (*Billy Codling*)

Fun and games to celebrate the 1953 Coronation in Browning Street. (*Ken Hughes*)

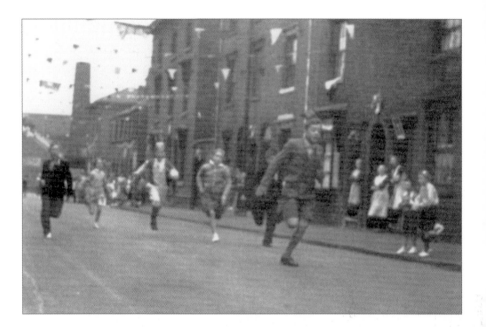

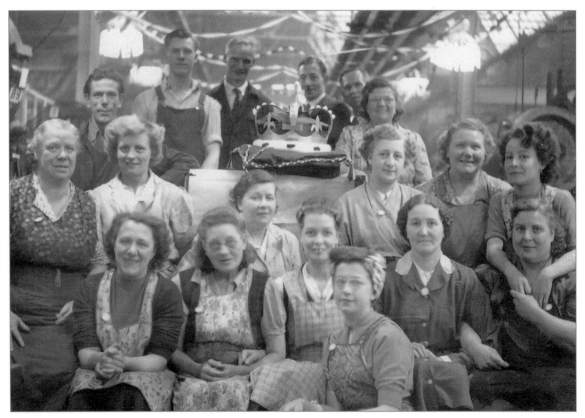

Workers pose with a crown they made to celebrate the 1953 Coronation. Most people stopped to put the kettle on, but here they just stopped making them as the celebrations got up a head of steam in the Press Shop at Bulpitt & Sons at Spring Hill. (*Terry Gorse*)

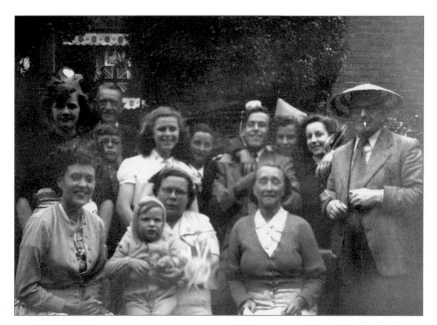

The 1953 Coronation celebrated in St Mark's Street. Mr Salmon is wearing the Chinese-looking hat. Mrs Salmon is seated with baby Roy and Kathleen Salmon is behind her mother. Other people include Jean Evans, Maureen Hunt and members of the Rainbow family. (*Terence Salmon*)

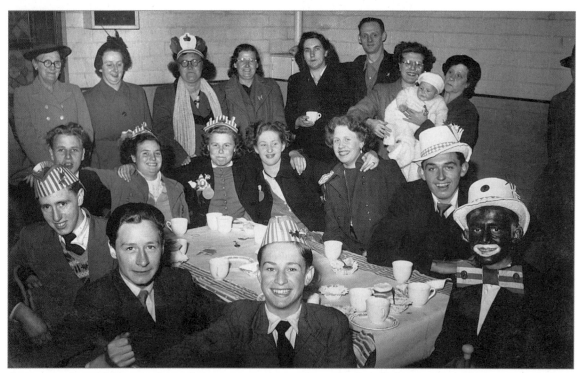

Coronation Day, 1953, at Ladywood Community Centre, formerly the old dispensary building on Monument Road, next to the swimming baths. Mavis Ridley recalls, 'We all lived in the St Vincent Street area except for Derek Ridley who moved to Rednal from Icknield Port Road but still went to Osler Street School. The adults standing up include Mrs Chare, Mrs Hanson and Mr and Mrs Taylor. The youngsters sitting down are, front centre, clockwise, John Bradbury, Ken Walker, Don Corfield, Derek Ridley, Mavis Chare, Barbara Robinson, Stella Bradbury, Doreen Mason, John Barratt and the Minstrel is Ray Young.

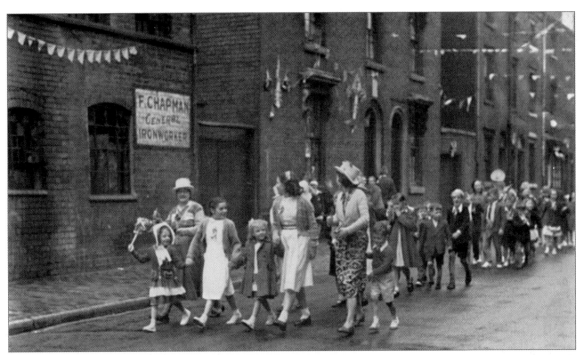

A 1953 Coronation procession passes the premises of Chapman's on Browning Street. Val Ling is the girl at the front waving a rattle and the lady behind her with a hat on is her gran. Barbara Eden is the tall girl in a white dress and other people on the front row include Jean Price and Michael Fisher. (*Val Rutter, née Ling*)

Coronation Day 1953, or a wedding around that time, at the Red Lion pub, Warstone Lane. David Curley is the fourth lad from the left and next to him is Donald Yates. (*David Curley*)

All boys were allowed to go into the playground at 10.45 or about 10 minutes to see the airship R101, which made a circle of the district & there a good view considering how surrounded with buildings the playground is. The occasion was improved by the teachers by a short talk in each class on the R101, oc.

Feb. 10th A Wireless Receiving Set. — purchased from the School funds — was installed today and B.B.C. Broadcast to Schools, in the following subjects are to be listened to. Music. Cls i + ii. History Cls ii + iii. Discovering England Cl. T

Extracts from school logbooks depicting events of interest. The R101 airship flew over Ladywood in 1929 and a wireless arrives at Nelson Street School in 1936.

Victor Yates MP, right, meets Peter Marriner of Marroway Street at a CND lobby of Parliament in 1962. Victor Yates was a clerk at Cadbury's before becoming MP for Ladywood from 1945 until 1969. (*Peter Marriner*)

A group of current Ladywood residents got together to form the Ladywood History Group in the year 2000, and with the help of a grant from the Millennium Awards set up the local history magazine the *Brew 'Us Bugle*, edited by the author of this book. The grant also paid for a number of photographs to be enlarged to form a permanent exhibition of the changing face of Ladywood at Ladywood Health & Community Centre on St Vincent Street. Centre manager Jan Stebbins, middle, takes a look at some of the pictures with the help of Jean Brown, left, and Edie Ockford. (*Eileen Doyle*)

Two former next-door neighbours were reunited after meeting up again following the launch of the book *Ladywood Revisited*. Rita Hunt, née Hollins, and June Daniels, née Spencer, with the book, lost touch as teenagers after their homes were demolished in Beach Street. They are seen with a large picture of their former street with husbands and author on the grass adjacent to Ladywood Arts & Leisure, on the exact spot where they both lived.

A community procession led by Brian Gordema-Braid and Jan Stebbins moves along St Vincent Street, *c.* 1990. Blythe Tower, on the right, has since been demolished. In the distance, Ledsam Street runs off to the left.

The first reunion of former St Peter's School was held at Ladywood Social Club in July 2002. Pictured here are Doreen Edwards, née Wilson, and her sister Nora Bartlam. They are with former St Mark's Street neighbour Ricky Tiernan.

Another trio of former St Peter's School friends who met at the reunion in July 2002: Joan Chambers, Joan Taylor and Arthur Kennedy.

5

Leisure

The Edgbaston Cinema, Monument Road, *c.* 1967.
(*Ken Greaves*)

The front cover of the February 1898 issue of St John's parish magazine. The magazine announced, 'The Bishop of Worcester will be holding a Confirmation on March 31st'; meanwhile it was confirmed that 'parochial tea is set for Shrove Tuesday'. The calendar informed parishioners of the Young Women's Bible Class, Shoe Club, Penny Bank and the Sunday School Teachers' Prayer Meeting. A bus timetable was included. Buses run by Thompson's Omnibuses ran into the city from the corner of Monument Road and Ladywood Road at 8.10, 8.30, 9.50, and every 20 minutes till 10.10 p.m., fare 2d. (*St John's Church Archive*)

Vicar of St John's Church, Canon Norman Power, carries out a baptism. (*Billy Codling*)

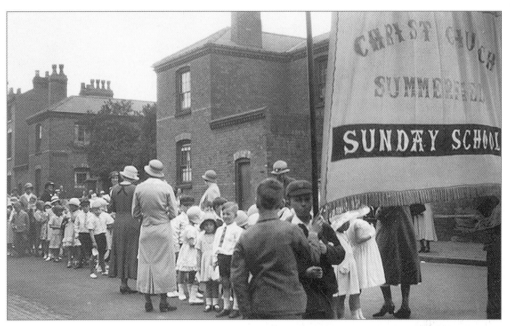

A Sunday school event, Coplow Street, *c.* 1935. Jill Kershaw recalls, 'This was the church hall, an annexe to Christ Church. I lived up an entry further along the street. Icknield Port Road is in the distance.' (*Jill Kershaw*)

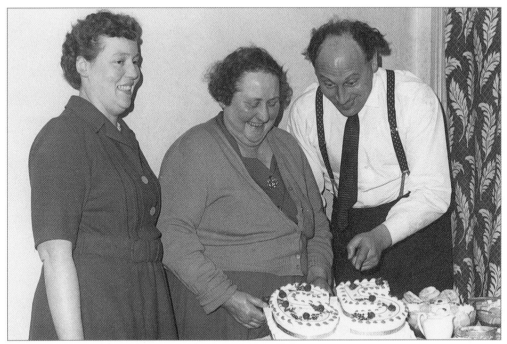

Jill Kershaw says, 'This was taken on my mother Doris's sixty-fifth birthday in 1964. She was born in Coplow Street. I'm on the left and my Dad Jack is with us to cut the cake. She worked at Gateley's chemists, scrubbing and cleaning. She died with brown patches on her knees! She was a good mother.' (*Jill Kershaw*)

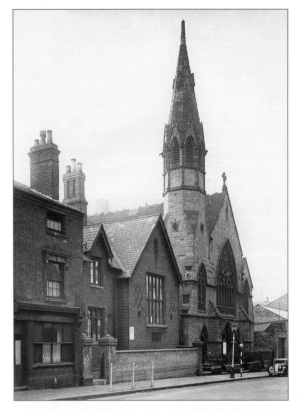

These three well-known Ladywood churches have all been demolished. *Top left:* St Barnabas's Church on Ryland Street, 1957. *Top right:* The remains of St Michael's Church in Warstone Lane cemetery. *Bottom left:* The interior of St Peter's RC Church off Broad Street. In 1958 the priest was Cuthbert Brown.

The continuing success story of the
Plough & Harrow – a name which
reflects the once-rural area in which the
hotel was first built in 1704. It has been
rebuilt since then and the Hagley Road is
now a modern thoroughfare. When
traffic there is at a standstill motorists
can gaze at its fine architecture.

There is a warm welcome at Birmingham's most prestigious
hotel, with highly acclaimed food and the finest wines.
Special Dinner Menu: £24.50 – English Luncheon: £17.50
A la carte and Gastronomique Menus.

Hagley Road, Edgbaston, B16 8LS Tel: 021-454 4111 Telex: 338074

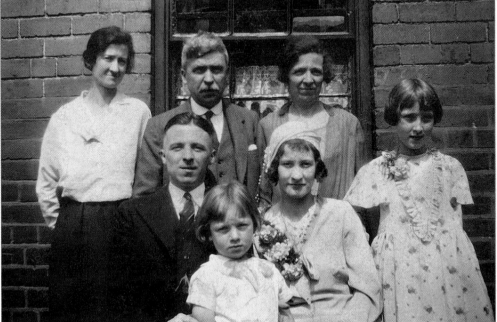

The wedding reception of Joe and Ada Green, which was held at the White Swan in 1933.
Behind the happy couple are Liz Ward, Grandad Martin, Mrs Martin and Eileen, a bridesmaid.
(*John Green*)

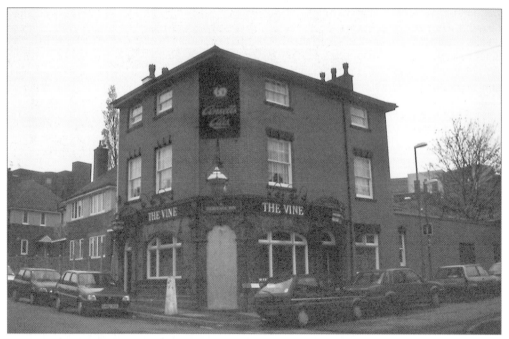

The Vine, Ruston Street, October 1992.

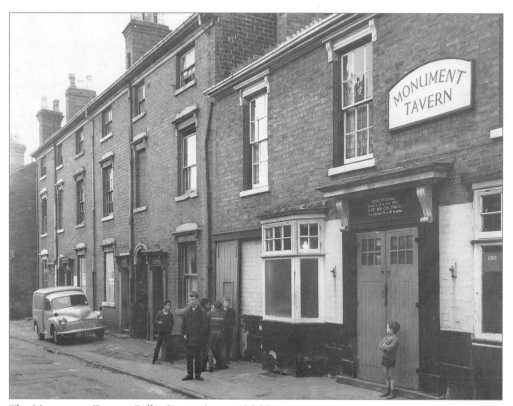

The Monument Tavern, Bellis Street, August 1969.

Outside the Bingley Arms.
Mr Smitheson recalls,
'Tommy "Nobby" Talbot,
who is the man at the back,
won a best turned-out shire
horse competition and got a
trip to the Guinness Brewery
in Ireland. They had crates of
Guinness piled up on the
train and were singing their
heads off when they got back
home. Everyone could hear
them and started saying
"Nobby's back!"'
(*Mr Smitheson*)

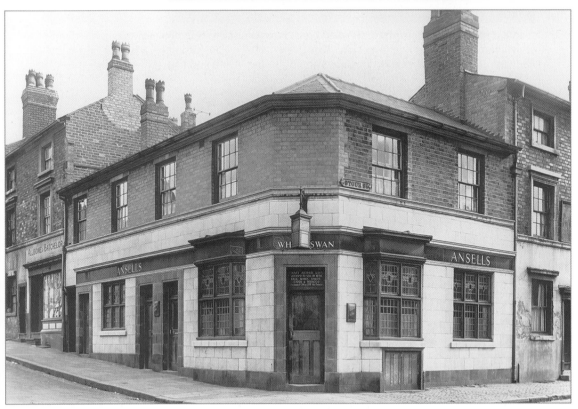

The White Swan, Stour Street. The landlord at the time was Sidney Arthur Lewis. Next door is a branch of
Allibone & Batchelor.

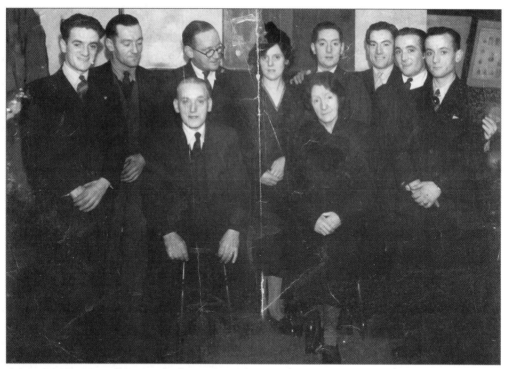

A late 1940s scene from inside the Red Lion, Warstone Lane. Members of the Curley family, which ran the pub, are pictured here. Left to right: Billy, Con, Grandad, John, David Curley's dad with glasses on, Auntie Doris, Nan, Tommy, Jimmy, Terry, and Leo. (*David Curley*)

'My Mom and Dad, Win and Jack, at their pub, the Red Lion, on Warstone Lane. They moved there in 1941 after being bombed out of the Turk's Head pub near Smallbrook Street and they ran this establishment until 1954.' (*David Curley*)

Charlie Hatley, centre, in the backyard of his pub, the Station Inn, Cope Street, early 1920s. His two companions are Ray Usher, left, and the man who ran the tobacconist shop on the corner of Shakespeare Road and Monument Road. (*Ray Usher*)

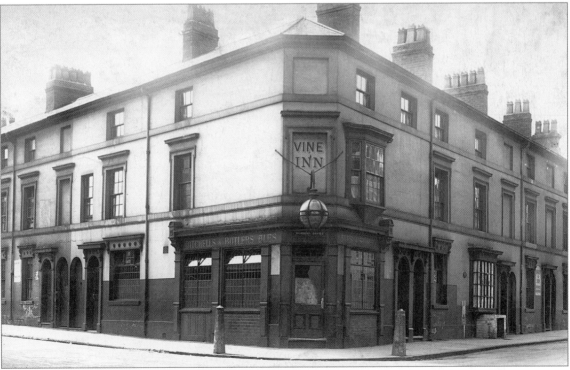

The Vine Inn at the corner of King Edward's Road and Garbett Street.

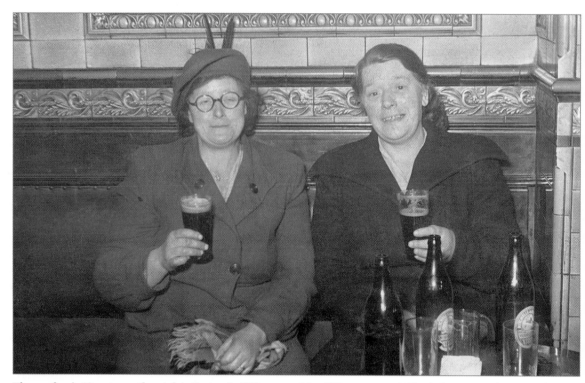

The author's Nan is on the right, Gertrude Wilson, er, Mrs Wilson to you! The lady next to her is unknown but she too looks a formidable but friendly person. Can anyone identify where it was taken? An educated guess would be the Warstone, as that was once one of Nan's preferred pubs.

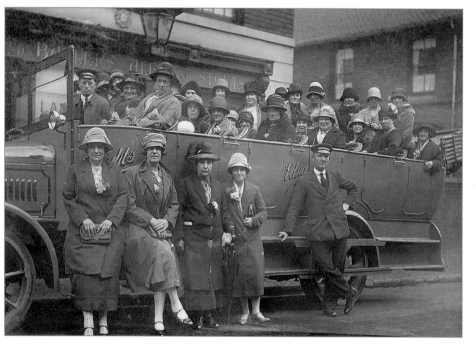

Outside the Rose & Crown at the corner of St Vincent Street and Sherborne Street in the early 1930s. Rosa Hall is one of the ladies who are sitting down, and to help identification she is wearing a hat! (*Rosa Hall*)

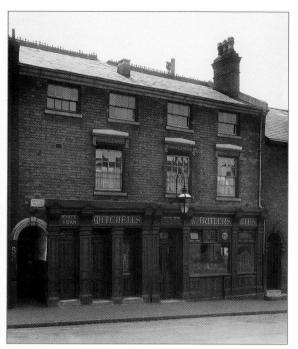

The White Swan on King Edward's Road.

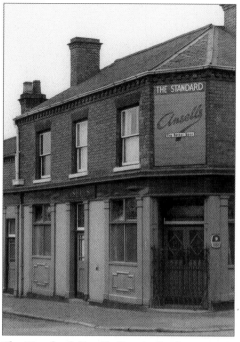

The Standard, Freeth Street, also known as the Cuckoo.

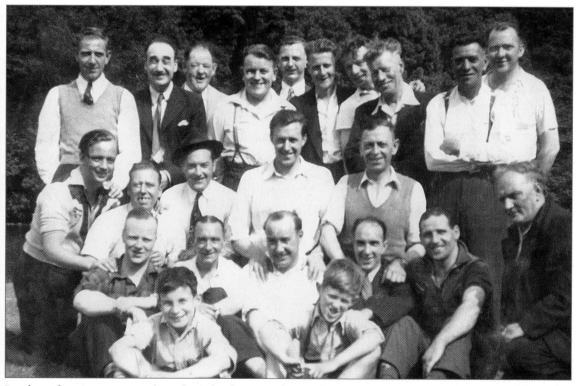

Local people enjoy an outing from the Ryland Arms pub on Ryland Street to Symonds Yat, *c.* 1955. (*Bill Starkey*)

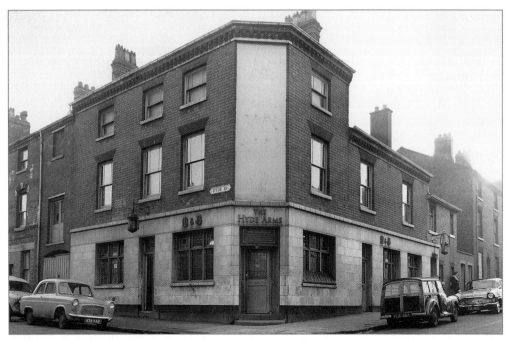

The Hyde Arms, Hyde Road. Last orders were called on 4 November 1968 when locals no doubt reminisced and sang the current number-one hit song 'Those Were The Days My Friend' by Mary Hopkin.

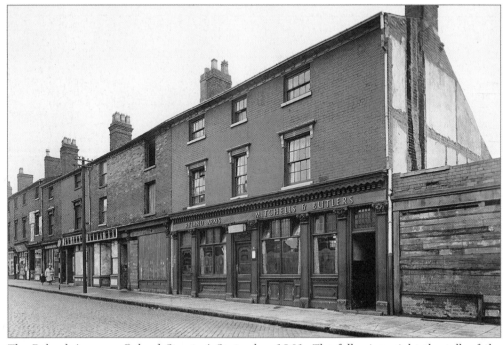

The Ryland Arms on Ryland Street, 4 September 1961. The following night the talk of the pub would have been West Brom's 6–0 thrashing of Newcastle United at The Hawthorns. (*Johnny Landon*)

The Commercial.
(*Ken Greaves*)

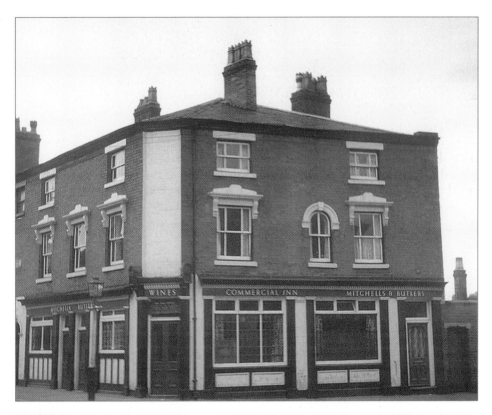

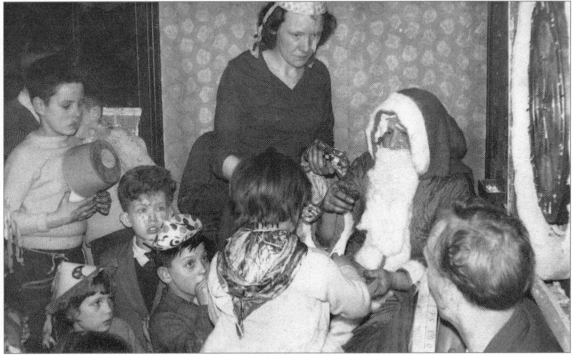

Christmas time at the Commercial. (*Billy Codling*)

The Pied Piper opened in February 1967 on a site between where the Stour Valley and the Bridge Inn were once situated at the corner of Ledsam Street and Ladywood Middleway. This pub is now a Chinese centre.

The Ivy Bush, at the corner of Hagley Road and Monument Road, August 1963.

In the grounds of the Bellevue at the junction of Icknield Port Road and Wiggin Street, *c.* 1938. Once a month dog shows were held in the pub grounds and small prizes were awarded to the owners of the best dogs. The back row includes Fred Kilby, ? McGregor, ? Tennant, Fred Logan and Bob Bennett. Middle row includes Bill Palmer and Tug Wilson. Two of the characters on the front row are Matt Henderson and Mick Evans. (*Roy Edwards and Alex Henderson*)

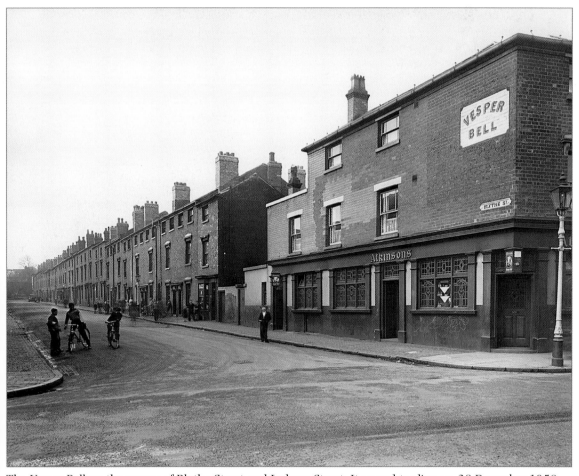

The Vesper Bell on the corner of Blythe Street and Ledsam Street. It ceased trading on 28 December 1958.

A group on a charabanc trip from the Ivy Green pub in Edward Street. The group includes Edith Doe, née Goode, Violet Trapp, Nin Mears, Mrs Wallington and Ada Goode. (*Betty Field*)

The Crown, Springfield Street. (*Trevor Williams*)

The exact location of this late 1960s photograph is a mystery, but the author's Nan, in fur coat and glasses, is on it, indicating it may have been an outing from Ladywood Social Club, but is more likely to be a works outing from Bulpitt & Sons. Auntie Kath who is standing next to Nan worked there at that time and her work mates may not necessarily have been from the immediate area, but some of those identified include Dave Morris, Vera Brunt, H. Downing, John Murphy, Ann McWilliams, Jean McWilliams and Cissy Murphy.

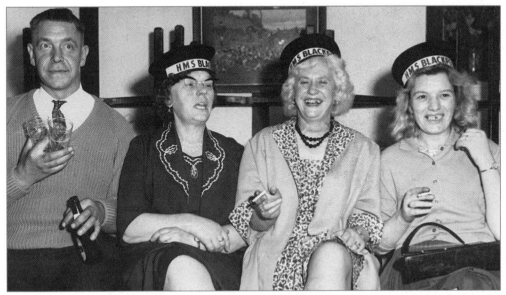

Probably taken on the same trip as above. Their destination was clearly Blackpool, though how much of Blackpool they actually saw is debatable given this happy scene from a pub, no doubt near the seafront. The unidentified man's job appears to be to hold the ladies' glasses until they finished singing! Next to him are Nan (Mrs Wilson), -?-, and one of Nan's daughters, Kathleen, at the far end.

Henry Mitchell at Cape Hill merged with William Butler to form the familiar M&B Brewery. Following numerous takeovers, the current owners of the Cape Hill site decided to close it in 2003.

The Palais de Danse in 1933. The hall opened on Monument Road in 1920 and advertised itself as 'The Sensation of the Midlands'.

The Boys' Brigade was always very popular in the Ladywood area. Top left is Terry Hyde aged fourteen in 1948; top right, Terry is with pal Clifford Hawkins at the campsite in Harlech, *c.* 1947. The threesome, at the same camp, are Gordon Cull, Maurice Chadwick and Vic Stapleton. Maurice recalls, 'After the restrictions on holidays during the war, the BB camp, 4th Company, was THE holiday of the year. Strict discipline was maintained but there was a great spirit of friendship. The officers, George Stokes, Jim Irons and Rupert Wastell, were all much respected. You did your wack of chores in the camp kitchen, as per spud bashing. Sports and daily visits to the beach were enjoyed, but there was also the daily kit inspection outside your tents!'

Phil Trentham, left,
and Bill Timms, both
of Morville Street, at
the 8th Birmingham
Boys' Brigade
Headquarters in
St Martin's Street.
(*Phil Trentham*)

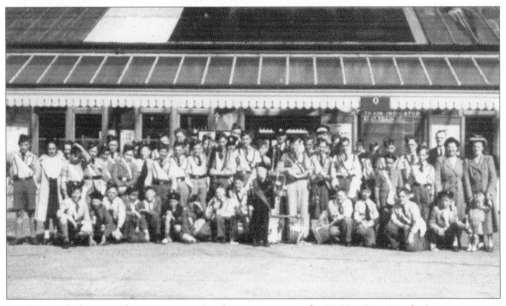

St John Ambulance cadets at Portcawl railway station, early 1950s. (*Ken Hughes*)

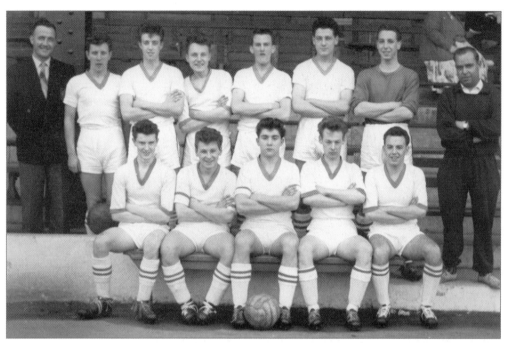

The cup final team of the Ladywood Methodist FC, otherwise known as the Hawthorns, at the Fortress of Dreams, 1960. Back row, left to right: Jack Wylie (assistant), Terry Malins, Kenny Orme, Frank Meddings, Berry Riley, Barry Wolsey, John Smith, Ray Gough (trainer, secretary and manager). Front row: Bernard Welch, John Weaver, Robin Lane (captain), Roger Colcombe, Colin Gibbs. (*Colin Gibbs*)

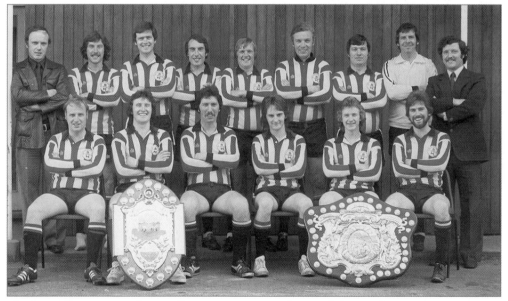

Championship winners from Belliss & Morcom. Back row, left to right: Pete Marriner, Bob Wyatt, Les Wood, John Gibbons, Bob Baker, Dave Taylor, Pat Sharkey, -?-, Melvyn Jones (manager). Front row: David Parker, Tony Hayden, John Gardner, David Flynn, Greg Farren, Jimmy Joyce. (*John Gibbons*)

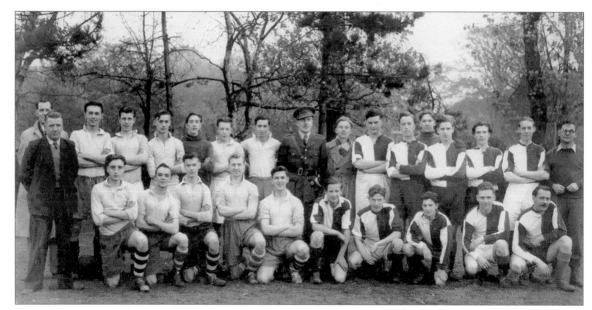

Barton's Screws FC of Ruston Street, *c.* 1949. Back row, left to right: Mr Bryan, Stan Sharp, Len Bryan, Pete Neill, Len Sharp, Gordon Hunt, Ray Matthews. Front row: Roy Smith, Ron Goodridge, John Spencer, Ron Bryan, Roy Tomkins. (*Roy Smith*)

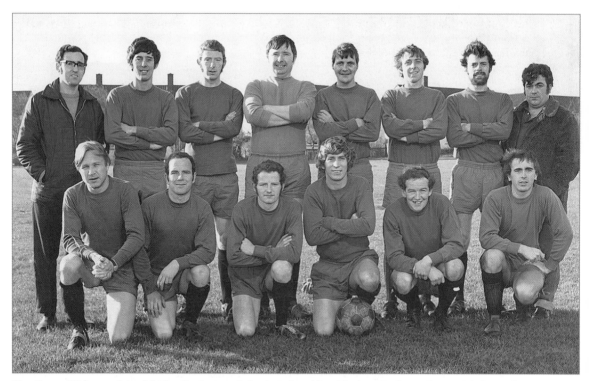

The Brew XI team, late 1960s. Back row, left to right: Alan Taylor, Graham Orme, Mickey O'Brien, Brian Narbit, Nicky Owls, Billy Parry, ? Vaughan, Billy Codling. Front row: Billy ?, Jimmy Cunningham, Tommy Cunningham, Timmy Sullivan, Bobby Cunningham, -?-. (*Billy Codling*)

'A quality goal by a quality player,' as Raymond Glendenning may have said had he been there! Ladywood boys in action for Keel or Kyle Hall FC of Gosta Green. Terry Wright, of Clement Street, and Albert Trapp, nearest the post, of Louisa Street, look on as goalkeeper Johnnie Tuplin, who lived in The Parade, grasps thin air at Shenley Park in the 1954/55 season. (*Albert Trapp*)

Ernest Gordon in action in a Belliss & Morcom departmental match at their Highfield Road ground in Quinton. (*Ernest Gordon*)

Charlbury United, a team made up of Ladywood-based lads, *c*. 1946. Back row, left to right: Dennis Clayton, ? Cook, Johnnie Meade, goalkeeper Raymond Teckoe, Gordon French, -?-. Front row: Teddy Aston (or Ashton), Ron Cresswell, Reggie Elmer, Harry Gregory, Bert Clackett, ? Taylor. (*Sue Teckoe*)

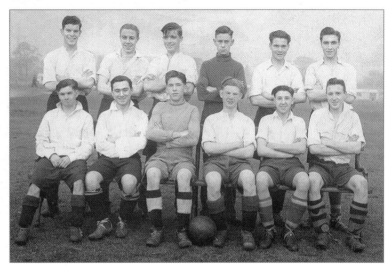

Belliss & Morcom had a thriving sports and leisure side to the business, aimed no doubt at keeping the workforce happy and healthy. Here Ray Jones, left, receives the Alfred Morcom Individual Snooker Handicap Challenge Cup from Mr J.E. Belliss in 1956. *Below:* Olive Welch is being presented with a tennis trophy in 1951/52. Ray says, 'We'd think nothing of cycling over to the Belliss & Morcom recreation ground at Highfield Lane, Quinton, straight after work. Belliss's created a happy family atmosphere when workers from the shop floor and offices socialised together.' (*Joan Jones and Olive Lovatt, née Welch*)

The interior of Spring Hill Library, 1910. (*Spring Hill Library collection*)

Fishing was always a popular pastime. These girls are the daughters of a group of fishermen from the club that was run from a pub on Cope Street in the mid-1950s. Bewdley was one of many popular destinations. Back row, left to right: Chris, Mary and Doreen. Front row: June, -?-, Meg. (*Alicia Foxall, née Watwick*)

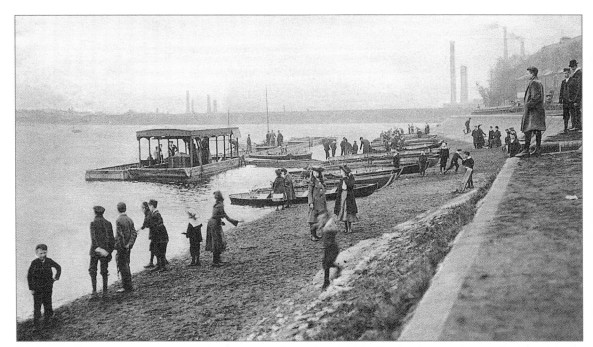

Edgbaston Reservoir on a postcard date stamped September 1904. The card was sent to Moseley with the message 'Come up tomorrow evening certain, as we have a surprise for you. With love Lizzie.' Get your imagination working on that one!

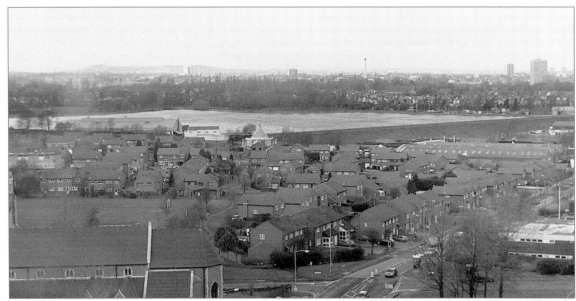

A present-day view of Edgbaston Reservoir showing what was once described as 'the largest expanse of water in the Midlands'. The new spire of the Buddhist Peace Pagoda on Osler Street is in the centre of the photograph. To the left can be seen the grey roof of the TS *Vernon* headquarters. The modern housing has replaced the terraced houses on Osler Street and Clark Street. In the bottom-left corner is St John's Church and the grass behind it is the Oratory School playing field. The major road is Icknield Port Road and the remains of Monument Road cross it, with the fire station on the right.

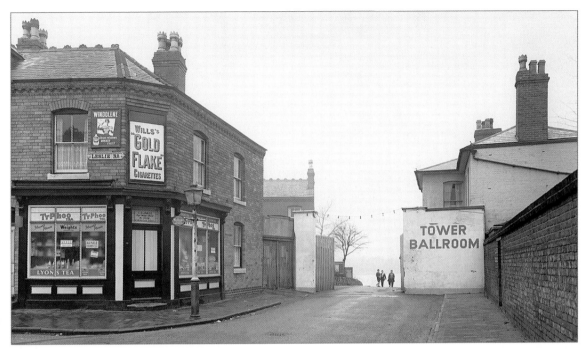

The main entrance into Edgbaston Reservoir. Anthony Spettigue remembers, 'The shop on the left was a greengrocer's run by Mr and Mrs Jukes, selling quality vegetables with a friendly service. It is now the Reservoir Café.'

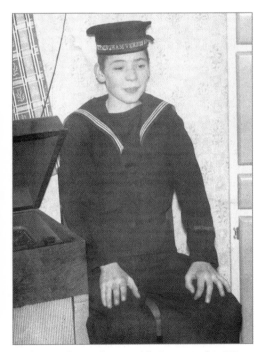

Arthur Wilson of St Mark's Street in his TS *Vernon* Sea Cadets uniform.

A biplane comes in for a watery landing on Edgbaston Reservoir. The tower of Osler Street School can be seen in the background. Can anyone put a date on this occasion, which presumably was a rare event?

The conductor in the white jacket is Les Douglas, a popular performer at the Tower Ballroom during the postwar period. The singer (seated) is Joan Baxter. Standing, left to right: Geoff Kaye, Bill Keyes, Bill Leeson, Vic Mortiboys. Seated: Gerry Alvarez, Eric Entwhistle, Leon Cochrane, Tass Hobart. Reg Tilsley is at the piano. Notice the emblems on the music stands comprise RAF wings and hearts. Roy Edwards says, 'As they don't appear to be playing trombones, I'd say it was taken in 1947 or 1948.' (*Les Douglas*)

Les Douglas, again in his white jacket at the Tower Ballroom, is on the far left behind the accordion player. Joan Baxter is singing again. Les Douglas ran the RAF Bomber Command Orchestra during the Second World War, and formed this band after the end of hostilities. (*Les Douglas*)

The Tower Ballroom, 1947. Left to right: George Trevitt, Derek Fowler, Brian Kennedy and Raymond Perks. The three in uniform were on leave from their National Service. All four lived in Osler Street, went to the local school together and met up whenever they could afterwards. (*Derek Fowler*)

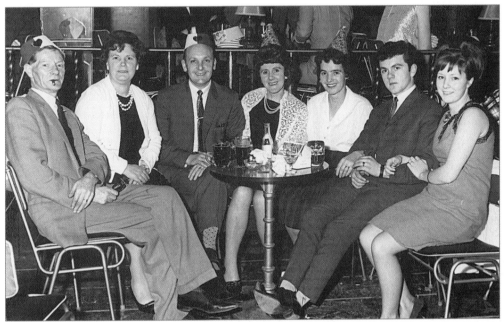

A family get together at the Tower Ballroom, mid-1950s. Seen here are, left to right: -?-, Agnes Evans, Jack Bartlam, Kath Bartlam, Nora Wilson, Derek Bartlam, -?-. (*Nora Bartlam, née Wilson*)

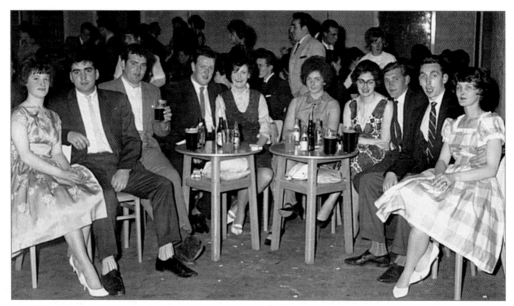

Members of the Landon family prepare to knock spots off people, in the nicest possible way, for this was the domino league presentation at the Tower Ballroom in 1960. Only Bill was in the team but the others went along to give their support in the best way they could. Bill was a member of the successful domino team based at the Albion pub in Sheepcote Street. 'With a name like Albion it's not surprising the team was a winner!' Left to right: Maggie, Tony, and Johnny Landon, Doug Watts, Maggie Watts, Ann Landon, Sheila Room, John Room, Bill and Doreen Landon.

West Bromwich Albion Supporters' Club Player of the Year Night at the Tower Ballroom, May 1998. The central three people Norman Bartlam, Kevin Candon and Richard Ryan hand over the proceeds of a book they wrote called *Five & A Half Legs Go Nationwide* to Alison Brettle of the WBA Disabled Supporters' Club. The book helped raise awareness of the problems disabled supporters face as they visit football grounds around the country. West Bromwich Albion's Dutch international midfielder, Richard Sneekes looks on to see fair play.

The former Crown Cinema where many local children spent an enjoyable Saturday afternoon, *c.* 1985. It is at the junction of Icknield Port Road and Freeth Street. Today it is the home of Bill Landon & Sons' bathroom centre. Next door is a garage, formerly known as Lilley & Stensons. Next door to that is the former Kodak factory, which was once a billiard hall, where presumably you could get your photos right on cue! At the top of this aerial shot is Ladywood School, opened in 1972 to replace Osler Street School, which closed in 1990.

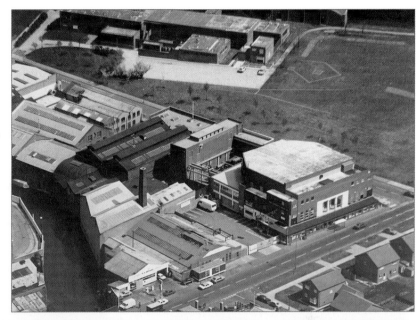

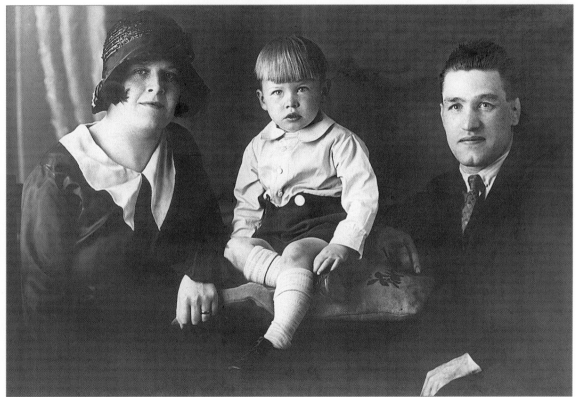

Boxer Len Fowler on the right with his wife Maud (née Crowther) and one of his sons, Leonard, aged about three, in 1929. Len was from Steward Street and Maud from Osler Street. His other son, Derek, is researching his dad's career. Did anyone see him fight? Derek says, 'Dad was a well-known boxing star of the day and he became the Midland Bantamweight Champion in 1924.' (*Derek Fowler*)

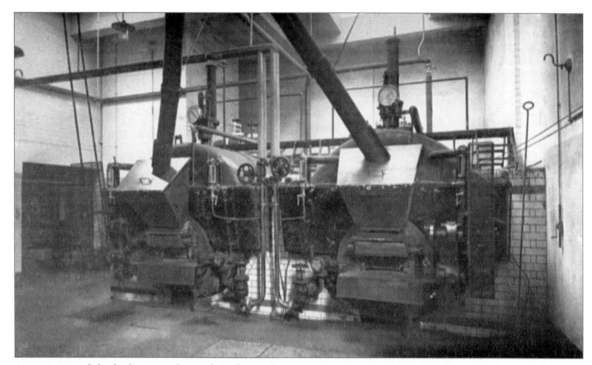

A rare view of the boiler room beneath Ladywood Swimming Baths. Just prior to the outbreak of the Second World War it was decided to demolish the existing Victorian baths and replace them with a modern establishment on the same site. The size of the new baths was restricted by plans for the new building line for Monument Road.

A regular Ladywood scene; a boy with a rolled up towel under his arm as he heads off to the swimming baths on Monument Road. This is Clifford Greaves with Michael Greaves behind him at 16 Shakespeare Road on a gloomy autumn day in 1962. (*Ken Greaves*)

The foam bath at Monument Road Swimming Baths.

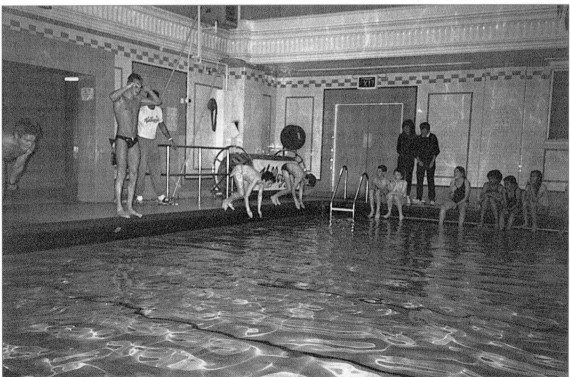

It was called 'a bit of a dive' in its later years, but Ladywood Swimming Baths holds many happy memories, and no doubt a few sad ones as well for those who failed to learn to swim, in spite of the guidance given by patient teachers! Here pupils from Ladywood School take the plunge in October 1988.

Development of the area off Ladywood Road in the late 1950s and early 1960s gave rise to the new Chamberlain Gardens. A number of recreational facilities were provided for the people who lived in the high-rise tower blocks, which included a paddling pool. Here Dawn Blake is having a paddle during the summer of 1976. The pool has now been filled in. (*Val Blake*)

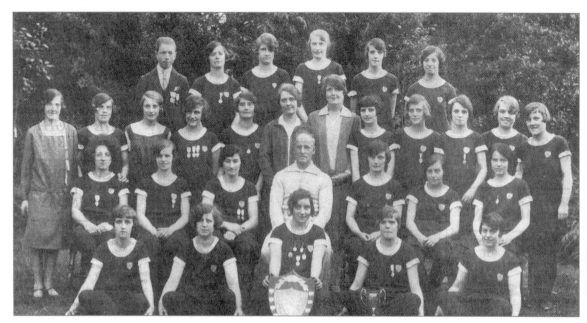

Boys and girls show off a trophy and their medals at St Barnabas's Gym Club, *c.* 1928.

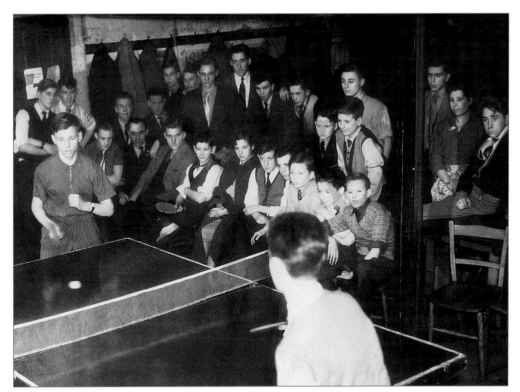

The final of the Ladywood Methodist Youth Club table tennis competition, 1952. Morris Kriss, the Warwickshire number one table tennis player, was in attendance as David Collins beat John Welch in the final 21–15, 21–17. The beaten semi-finalists were Alan Mitchell and John Cloves. Ladywood Methodist Church was on Monument Road almost opposite the swimming baths.

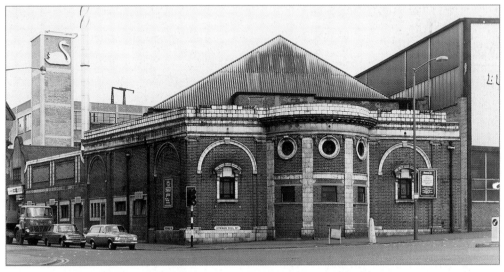

The former home of the Palace cinema, which opened as a theatre in 1905. It soon became a cinema and closed in about 1962. This photograph dates from March 1973 when the building was in use by neighbouring company Bulpitt & Sons. The tower in the background proudly displays the Bulpitt Swan Brand logo.

Shirley Cleary on her new bike in Summerfield Park, *c.* 1952. She says, 'My gran, who lived three doors away from me in Springhill Passage, told me and my sister that the first one of us to learn to swim would get a bike. I was about ten or eleven at the time and a bike was beyond my wildest dreams. I started learning to swim at Monument Road Baths, it was a penny to get in, I ended up a good swimmer but my sister still can't swim. I never got the bike until I was thirteen, but I'll always be grateful because without her promise I would never have been so determined to learn to swim.' (*Shirley Goode, née Cleary*)

Lazing about at the bandstand in Summerfield Park, 1892. This structure was replaced in 1907: see *Ladywood in Old Photographs*, page 130. (*Spring Hill Library collection*)

Fun Day in Ladywood, July 1982. 'Soak A Probation Officer' was the name of this game. It was 10p for three throws! This was taken from outside Ladywood Methodist Church on St Vincent Street not far from the site of the Ledsam Picture House. St John's School is in the background and the now demolished flats and maisonettes on the Gilby Road estate are in the distance.

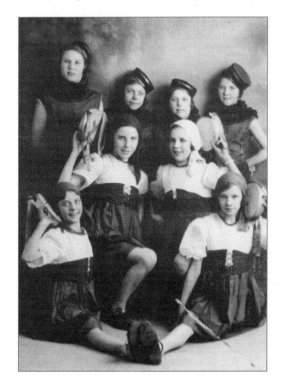

A pantomime at St Margaret's Church, 1934. Betty Rooke recalls, 'It was organised by Mrs Harper, a piano teacher from St Vincent Street, Father Foulkes and Father Charles. I am on the front row, immediate left, and I was twelve at the time. Nora Riley is at the end of the back row, far left. Her family were coal merchants in Friston Street. Next to her is Evelyn Parker. Sadly they were both killed during a bombing raid over Friston Street. The girls next to them are called Joyce and Joan. The two girls on the middle row are Alma MacNamara and Mary Hammon. Dolly King is the girl who is sitting on the floor next to me. The pantomimes were great fun and we seemed to do them every year. We also had an annual trip out to places like Bryant & May's match factory. We had a brown bag that consisted of two sarnies and a cake. It was really great fun and not to be missed. We really looked forward to it.' (*Betty Rooke, née Hammon*)

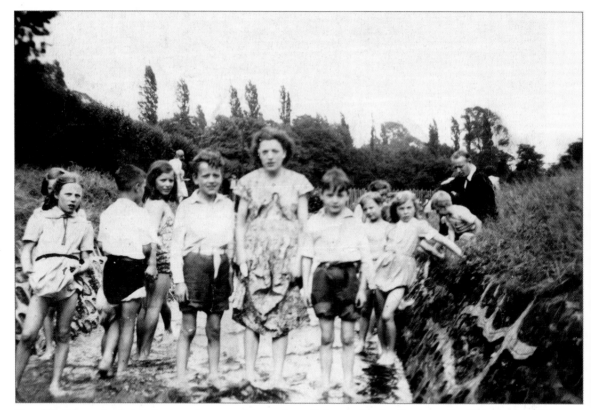

You didn't have to go too far to enjoy your leisure time. Fed up with the Rezza or the Lickeys, then why not go to Cannon Hill Park? Kathleen Quinlan and friends go for a paddle, late 1950s.

Broadway Plaza is a modern leisure facility for the people of Ladywood. In days gone by they attended small local cinemas such as the Palace, Lyric or New Regent: see *Ladywood in Old Photographs* and *Ladywood Revisited*. In addition to cinema screens, this new complex, on the site of the former Children's Hospital, includes a fitness centre, bowling alley and fast-food outlets. The façade of the hospital has been retained, and the new residential blocks beside it are seen in this view from 2003.

A New Year's Eve Dance at Parker, Winder, Achurch on Broad Street, 1950. Left to right: Florrie Goode, -?-, Vera Taylor, Mary Gauder, Margaret Plummer, Fred Gauder. (*Margaret Plummer*)

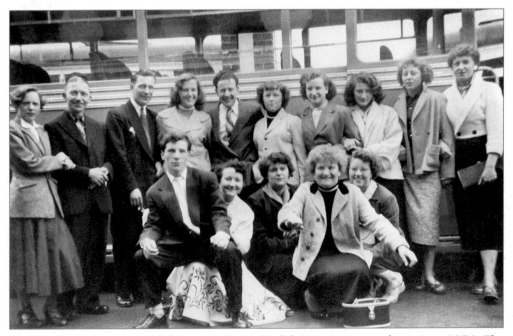

Workers from the Advanced factory in Great Tindal Street, on a works outing, 1956. The Advanced was officially known as the Advanced Pressure Die Casting Co. Ltd, but the pressure was definitely off as this group of workers relax on a trip to Blackpool. The workers include Shirley Goode, Ruth Deathridge, Rose Saunders, June Saunders, Lily Murphy, Annie Hunt, Sylvia Mitchell and Barry Steele. (*Shirley Cleary, née Goode*)

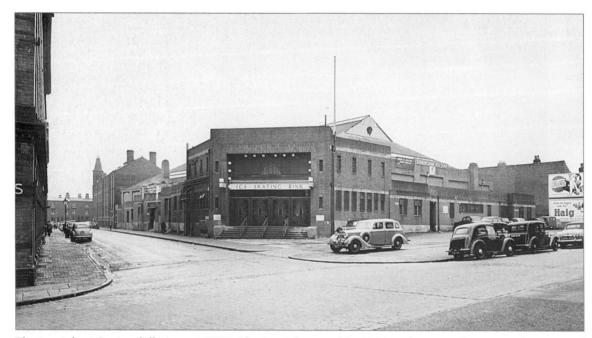

The ice rink at Summerhill, August 1957. The ice rink opened in 1931 and was on this site at the corner of Summerhill and Goodman Street, left, until 1964. For a few years the building became a roller-skating rink and then a car showroom before being redeveloped as a stationery warehouse, which has now ceased trading.

Kleenskates were the wipes used to clean and dry the blades of skates by the hundreds of skaters that used the ice rink each week.

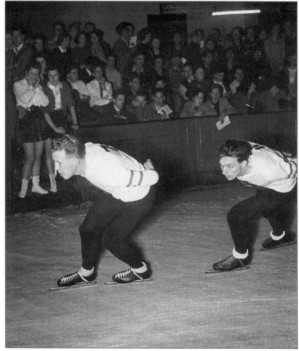

Pete Jennings, at the front, of the Birmingham Mohawks speed skating team. (*Dena Hargreaves*)

Dena Hargreaves shows off her ice skating trophies with her dad Ronald and skating partner Arthur Jeffries, *c.* 1957. Dena won her first trophy at the age of eleven. She turned professional in 1961. She got her skates on and moved to the new Silver Blades building and became the British Professional Pair Skating Champion with Bernard Fletcher in 1965, making her the fourth or fifth best in the world. Clearly skating was a serious business, but there was room for enjoyment too, as on New Year's Eve when she dressed up for the annual fancy-dress night. The necklace was made from 'teeth from a boiled sheep's head; there was an awful smell,' she says! (*Dena Hargreaves*)

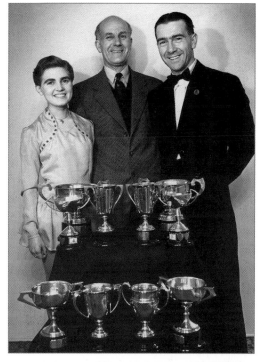

Below: The Mapleleaf Ice Hockey team at the Summerhill ice rink. (*Dena Hargreaves*)

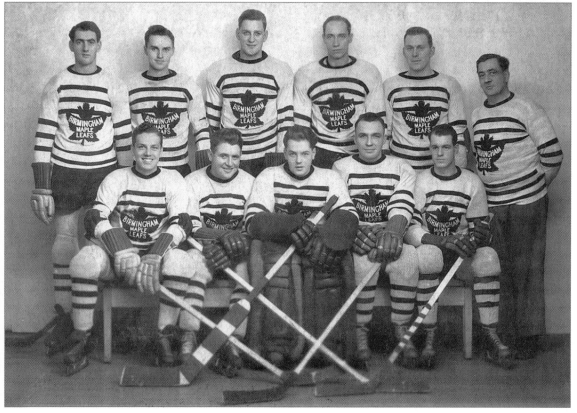

Index of Streets